C000154709

LIGHTSHIPS

LIGHTSHIPS

Floating Lighthouses of the Mid-Atlantic

Wayne Kirklin

Charleston London

History
PRESS

Published by The History Press
Charleston, SC 29403
www.historypress.net

Copyright © 2007 by Wayne Kirklin
All rights reserved

Cover image: LV *118*, today's *Overfalls. Courtesy of the author.*

First published 2007

Manufactured in the United Kingdom

ISBN 978.1.59629.350.2

Library of Congress Cataloging-in-Publication Data

Kirklin, Wayne.
 Lightships : floating lighthouses of the Mid-Atlantic coast / Wayne Kirklin.
 p. cm.
 Includes bibliographical references.
 ISBN 978-1-59629-350-2 (alk. paper)
 1. Lighthouses--Middle Atlantic States. 2. Lightships--Middle Atlantic States. I. Title.
 VK1024.M54K57 2007
 387.2'8--dc22
 2007024696

Notice: The information in this book is true and complete to the best of our knowledge. It is offered without guarantee on the part of the author or The History Press. The author and The History Press disclaim all liability in connection with the use of this book.

All rights reserved. No part of this book may be reproduced or transmitted in any form whatsoever without prior written permission from the publisher except in the case of brief quotations embodied in critical articles and reviews.

For Annie, John, Kevin and Daniel.

A history preserves memories for the next generation.

Contents

Acknowledgements

This book is the result of the help and encouragement of many individuals. Rachael Wynne at the Columbia River Maritime Museum first suggested that I write about lightships. David Pearson, curator of that museum in Astoria, Oregon; John Byrne in Oakland, California; Shannon Fitzgerald at the Northwest Seaport in Seattle; Jerry Rome at the Huron Lightship Museum in Michigan and Greg Krawczyk at Baltimore's Maritime Museum all graciously shared the lightship in their care with me.

Jim Claflin suggested many sources of information and helped me gather the illustrations. Anne Carey shared some early internet searches. Brian Wilson of the National Park Service at Harker's Island, North Carolina, contributed to my understanding of Pamlico Sound.

David Bernheisel, president of the Overfalls Maritime Museum Foundation, and his wife, Mary, our local reference librarian, both provided material as well as support.

My lovely wife, Marian, and daughter, Julie, spent many hours reviewing the manuscript while Daniel Scott kept me out of the way.

Introduction

L ight boats, light vessels, lightships—these floating lighthouses were placed where mariners needed guidance but where it was impossible to build a permanent structure. Moored near shifting shoals, treacherous reefs or offshore where it was too far for a land-based light to reach, these craft played an indispensable part in keeping the nation's waterways safe for navigation between 1820 and 1985.

This narrative is about the eighty-five ships that staffed the forty-five stations along America's middle-Atlantic coast, ranging from New York Harbor to the southern border of North Carolina. It includes those vessels placed in the Delaware and Chesapeake Bays and the two sounds of North Carolina.

Today these lightships are largely unknown to the general public and are taken for granted by the maritime industry. Although modern technology has rendered these vessels unnecessary, the design, life and adventures of these heroic ships are fascinating.

Light vessels have existed since ancient times. In 1732 the first modern lightship was born in England when Robert Hamlin, a successful barber and ship owner with financial resources, and David Avery, a poor but resourceful man, combined their efforts to place a vessel marking a sandbar at the mouth of the Thames River.

This small, commercial ship had a lantern fixed at each end of a twelve-foot wooden pole, which was hoisted up the mast. At first the light was provided by tallow candles and later by flat wicks in oil. It was difficult to keep the vessel on station and to keep the lamps lit, but the venture proved profitable, supported by dues collected from passing ships. Seeing these results, Trinity House—originally chartered by Henry XIII and charged with the duty of praying for sailors lost at sea, and as the years passed, accountable for keeping various sea marks in order—soon assumed responsibility for this and other lightships. From this single lightship on

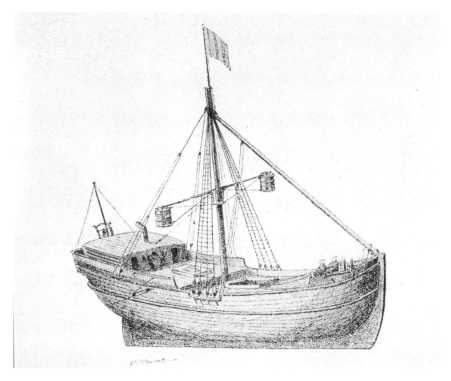

The first modern lightship, *Nore*, was placed in the Thames River in 1732. *Courtesy of the author.*

the Thames grew a large fleet scattered over the globe, which lasted until technology made the vessels obsolete.

The lightship era in the United States covered 165 years—between 1820, when the first small craft was stationed in the Chesapeake Bay, until 1985, when the last Nantucket lightship was decommissioned. During this time, 179 vessels were used and they covered 116 stations on America's coasts and the Great Lakes. This period saw dramatic changes in available technology and in the role of U.S. waterways. The lightships reflected these changes.

In 1820, wind propelled ships and candles and whale oil provided light. As the years went by, the challenge of providing aids to navigation for the maritime industry remained, while the tools available to meet this challenge underwent enormous change. By 1895 the ships were powered by steam and diesel. Then electricity, radio, radar and a host of other improvements were added to modernize the way the fleet operated.

The federal government's responsibility for maritime safety started with the passage of legislation by the first session of Congress on August 7, 1789. This bill established that the federal government would support building and

maintaining the country's aids to navigation. It provided that all expenses "in the necessary support, maintenance and repairs of all lighthouses, beacons, buoys and public piers erected, placed, or sunk before the passing of this act, at the entrance of, or within any bay, inlet, harbor, or port of the United States, for rendering navigation easy and safe, shall be defrayed out of the Treasury of the United States." The duties were assigned to the secretary of the treasury, Alexander Hamilton (1789–1795), who appointed the commissioner of the revenue to supervise the operation. This continued until 1820, when the care and supervision of the lighthouse establishment was assigned to the fifth auditor of the treasury, Stephen Pleasonton, who held the position for almost thirty-three years.

Pleasonton has been greatly maligned by many historians. He was a man of his time. A competent, hard-working, conservative administrator, he carried this assignment along with his main duties. In addition to the lighthouse service, he was responsible for all the diplomatic and consular accounts abroad, for domestic accounts pertaining to the Department of State and Patent Office, as well as those of the census and boundary commissioners, and for adjusting claims on foreign governments. At one time he also held the duties of the commissioner of revenue. For all this, he had only nine clerks working for him.

He delegated the authority over lights and lightships to the collectors of customs. These officials supervised aids convenient to their ports. They hired, fired, found and purchased the sites for lighthouses, contracted for the building of lightships, inspected their charges and saw that they were supplied. Much of the work was performed by contract. For this the collectors received a 2.5 percent commission on disbursements, but they had to get Pleasonton's approval for these expenditures. After 1822 they were allowed to spend up to one hundred dollars without prior approval. Still, during this period no one was compensated for the general administration of lighthouses, lightships and other navigational aids.

Pleasonton had no experience relating to maritime affairs and had limited understanding of maritime matters. He was not responsive to the group of engineering professionals starting to emerge in the early nineteenth century. A professional bureaucrat, he was a conscientious guardian of the public purse and was reluctant to spend money on navigational aids. In his report to Congress in 1842, he took pride in the fact that the American lightships were operated at one-fourth the amount Trinity House spent for the British equivalents. He did not recognize that this compared the finest system in the world to the United States system, which left a lot to be desired.

It was under his administration that this country's first manned lightship was constructed in 1820. This vessel was followed by four more—a second

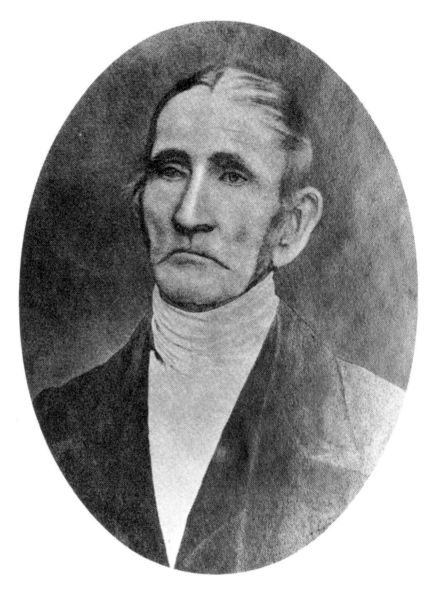

Stephen Pleasonton, fifth auditor of the U.S. Treasury, was in charge of lightships starting in 1820. *Courtesy of the Library of Congress.*

vessel to be placed in the Chesapeake, one for Sandy Hook in New York and two for the Delaware River in 1823. By 1825, Pleasonton had overseen the establishment of twelve lightship stations, although the one at Diamond Shoal off Cape Hatteras, North Carolina, was destroyed by the weather within three years.

The number of lightship stations gradually increased to thirty in 1840 and had reached forty-one when Pleasonton was relieved in 1852. Pleasonton's contracts were invariably given to the lowest bidder, most often one of his reliable cronies, even when the contractor had proved unsuitable in the past. Most notable of these was Winslow Lewis, a retired sea captain who developed an inexpensive version of the newly developed Argand lamp. Lewis's reflectors were more spherical than parabolic and were made of cheap materials that did not last during use. The price, however, convinced Pleasonton to adopt these as the standard, and they were regularly installed in lightships and lighthouses during the thirty plus years of Pleasonton's reign.

While navigational aids were being improved during this period, one question that sparked considerable debate among Congress and other interested parties was the use of running lights on vessels. The secretary of the treasury was instructed to survey the maritime community and report to the Senate. It was found that those surveyed had differing opinions. The pilots of Lewes, Delaware, felt that "the lights should be confined entirely to those vessels riding at anchor...the danger of collision is rather increased than diminished when vessels under sail are carrying lights, as it is almost impossible to tell the course they are steering." Mr. George Bush of Wilmington said "that vessels underway, or sailing, by having lights, might cause so much confusion in crossing and recrossing...that collision would unavoidably ensue...To steamboats this objection does not apply." One captain thought the requirement for lights would reduce the need for lookouts while traveling at night. The president of the New Jersey Board of Pilots, John Ellis, summed up the majority opinion stating "the showing of lights by all classes of vessels...would be of great benefit and might be the means of preventing much damage by collision, and thereby tend to the saving of life and property." This debate led to the passage of legislation in 1848 requiring vessels to carry specific running lights and instituted the lateral buoyage system that is now used.

By midcentury, growing criticism—from both Congress and the maritime community—about the country's aids to navigation resulted in the secretary of the treasury establishing a committee, composed of both military and civilian personnel, whose duty was to look at the condition of the lighthouse establishment. Its 760-page report "found the lightships...in bad order, badly attended, and all with...insufficient illuminating apparatus." Other

comments referred to the poor ground-tackle and mooring techniques and the lack of standardization of design. Also pointed out were the advantages of iron over wood for the hull.

This report led to the October 9, 1852 establishment of the Lighthouse Board. It also marked the end of Pleasonton's responsibility for navigational aids. The nine members of this new organization were drawn from the navy, the Army Corps of Engineers and some civilians. The board, as a separate branch of the treasury, instituted many important improvements in the lightship community. To improve supervision they divided the country into twelve districts and in each district placed an officer in charge of the lights and the personnel. Other improvements included acquiring more efficient illuminating apparatus, the construction of some new ships using a somewhat standard design and an attempt to upgrade the quality of the crews. The board set out a clear statement of rules and procedures with detailed instructions for masters of lightships.

The earliest American lightships were built with wooden hulls and were similar to merchant vessels of their time. This meant rounded hulls, which tended to be unstable and not suited for ships anchored in heavy seas. Although the committee's report recommended that iron vessels replace the wooden ones, it was a number of years later, and after ninety wooden ships were built, before this actually happened. Metal vessels were a new technology and there was a reluctance to move away from the wooden hulls, by both those in charge and those who built the ships. The wood ships could be made by eye, but the iron ones required more precise planning to assure the metal plates fit together. In the 1880s, there were thirteen composite ships built. These transitional ships had iron hulls sheathed in wood or steel frames with wooden hulls. Three iron-hulled ships were built before steel took over the job after 1891. These vessels carried steam equipment—not to power the craft, but to run winches and pumps and to power the sound signals. The boats were sailed or towed to their stations. The rapid rise in industrial technology after the Civil War caused monumental changes in the way ships were built. Steel production grew rapidly with the introduction of the Bessemer converter in 1856 and the open-hearth process in 1868. Plate steel became the resource of choice for the shipwrights because it offered a stronger material that was easier to repair. At the same time, the supply of good timber was diminishing. LV (Light Vessel) 51, the first steel lightship, was built in 1892 and served at Sandy Hook, New York, after two years in Long Island Sound at Cornfield Point, Connecticut.

Lightships have always been identified by the name of the station that they covered, but this made it difficult to keep track of the individual vessels as they moved among various stations. In 1867 the Lighthouse

Board directed that lightships be numbered consecutively from east to west, and these numbers were to remain permanent regardless of station. The Nantucket/New South Shoal lightship, the ship farthest east, became the first numbered light vessel, LV *1*. This method of numbering explains why the early assigned sequence of numbers is not the order in which the ships were built. While the coast guard changed the numbering series in 1939, it is the LV series of numbers that are used to identify the older vessels covered in this book.

Notable progress was being made. In 1870 Davenport Adams stated, "The United States stands next to Great Britain in the number of lightships which they support in the interests of commercial enterprise. At one time, however, their organization was very indifferent; but of later years the system followed in England has been adopted with few unimportant modifications."

The first steam-propelled vessels were built in 1891. This technology was not used for every vessel, and some ships equipped with steam still regarded it as auxiliary power and were towed or sailed to their station. These power plants did allow the generation of electricity that was first used aboard LV *51* in 1892, one of the ships that served for a time at the Sandy Hook station.

Diesel and diesel-electric power plants were considered as early as 1913. Engineers thought that these machines would eliminate the necessity for maintaining steam power twenty-four hours a day and for the obligatory amount of coal, since fuel oil weighs half that of the amount of coal required for a given horsepower.

A number of positive changes took place under the direction of the Lighthouse Board. Most notable were the improvements in illuminating and sound-making devices and the development of ways to distinguish one lightship from another. The qualities of the crews were improved and inspectors were stationed at each district to assure that standards were met. Although the structure of the Lighthouse Board and its committees was unwieldy, significant progress was achieved over the next fifty-eight years as the number of lightships in operation climbed toward its peak of sixty-eight in 1908. Most of these covered the fifty-three stations and the remainder served as relief vessels.

The Treasury Department still had the responsibility for lightships until July 1, 1903, when this charge was transferred to the Department of Commerce. The Lighthouse Board was disbanded in 1910 and a new Bureau of Lighthouses was established. This came under the able leadership of George Putnam that same year. Putnam, born in 1865, joined the United States Coast and Geodetic Survey in 1889 and spent

George Putnam, commissioner, Bureau of Lighthouses. Putnam served in this capacity from 1910 until 1935. *Courtesy of The American Lighthouse Foundation.*

twenty years establishing boundaries and improving charts. He went with Robert Perry to Greenland in 1896 and charted the Philippine Islands after the Spanish American War. It was here he met William Howard Taft, the governor of the Philippines, who later became president and appointed him to the Lighthouse Bureau.

Under Putnam's twenty-five years of leadership, the service became very professional. The equipment, work conditions, salaries and morale improved. New technology, when appropriate, was incorporated into the field. Most important was the 1921 introduction of the radio beacon as an aid to navigation.

The Bureau of Lighthouses continued as a separate agency until 1939 when President Roosevelt, in his reorganization of the government, placed this bureau under the United States Coast Guard, an organization that had resulted from the merger of the Revenue and Lifesaving Services in 1903. Personnel of the former bureau were given the choice of joining the coast guard or remaining as civilian employees. About half chose each option. The coast guard built six ships between 1946 and 1952. These were welded vessels and incorporated many safety improvements. Under the coast guard, which was by then using modern automated beacons, the need for manned lighthouses and lightships was significantly reduced and they were eventually eliminated.

Many of the retired lighthouses have been taken over by preservation groups and eight of the decommissioned lightships are in similar hands.

The following material is organized along both chronological and geographical lines and describes eighty-five lightships serving on forty-five stations. Much of the factual material comes from Willard Flint's compilation of data concerning the United States lightship fleet and the stations on which these vessels served.

Chapters One and Two look at the early inside lightship stations located in the Delaware and Chesapeake Bays. These two bays made up the country's most important commercial region during the end of the seventeenth century and first half of the eighteenth century.

Less important, but still significant, were the lightships stationed in the Albermarle and Pamlico Sounds of North Carolina, covered in Chapter Three.

Chapter Four is devoted to some of the technical aspects of lightships. It considers the development of their moorings, illumination and sound devices.

Chapters Five and Six explore the outside stations, those located in the ocean, from Nantucket to Cape Charles at the mouth of the Chesapeake Bay.

These two chapters are followed, in Chapter Seven, by a discussion of life aboard these ships that went nowhere.

The outside stations from the entrance of the Chesapeake Bay to the South Carolina border, and the ships serving on them, are discussed in Chapter Eight.

Chapter Nine, a concluding section, explores where the lightships have gone as their era expired.

Chapter 1

Inside Lightships—Delaware River

The Delaware River became the center of American life during the first two hundred years of exploration and development by European settlers. Robert Jewett, Henry Hudson's first officer, wrote in his journal that the *Half Moon* passed the cape (Henlopen) at noon on August 28, 1609. This "South" River was discovered before Hudson tried the "North [Hudson] River" as a possible Northwest Passage to the Orient.

About a year later, on August 17, 1610, Samuel Argall, an Englishman sailing from Virginia to Bermuda, was blown off course by a storm and took refuge in the bay behind Cape Henlopen. He named the bay in honor of Lord De La Warr, the governor of Virginia.

In 1620, Cornelius Jacobsen Mey (sometimes recorded as May) of Hoorn, Netherlands, sailing on the *Blyde Boodschap* (which means "good tidings"), thought he discovered the area and named the north cape Cape Mey and the cape to the south Cape Cornelius. Cape Henlopen, originally Hinlopen, was the Dutch name given at the time to Fenwick Island twenty-five miles south. Even though in 1682 William Penn directed that this south cape be called Cape James, the Henlopen name migrated north and prevailed.

In 1631, at the mouth of this bay, the Dutch West Indies Company established the first settlement of what was to become the City of Lewes. Farther up the river, Swedish immigrants under the leadership of the Dutchman Peter Minuit settled on the north bank of the Christina River in March 1638, forming the settlement that was to become Wilmington.

In the early 1640s the Swedes were also the first to settle Philadelphia, which was to become the country's largest and most important city through the eighteenth century. William Penn arrived in 1682, took command and laid out the city. Philadelphia thrived as a port, helped by its extensive and easily accessible hinterlands. The city served as the country's first capital city from 1790 until 1800.

Philadelphia's population reached 13,400 by 1750 and when the first census was taken in 1790 it had risen to over 42,000. The population of New York for the same periods was just over 13,000 and 33,000 respectively. Boston populations were 16,000 and 18,000. In 1790 Baltimore was reported to have about 13,000 people. By 1820 these numbers were 64,000 for Philadelphia, 124,000 for New York, 43,000 for Boston and Baltimore had grown to 63,000. While there was a shift in relative importance, these were the four major cities in the new country at this time.

Shipbuilding and commerce drove life around the Delaware River. One author called this river the Clyde of America—referring to the Scottish River where so many of Great Britain's ships were built. For many years the river was the center of the shipbuilding industry in America. Between 1726 and 1775 Delaware shipyards launched over three hundred vessels for coastal and foreign trade.

The major upriver shipyards included Cramp Shipyard in Philadelphia and New York Shipbuilding across the river in Camden, New Jersey. Here many of the largest vessels of the United States Navy were constructed as well as a great tonnage of other ships. At the southern end of Philadelphia the federal government had one of its principal naval yards at League Island.

Downstream in Wilmington, Pusey and Jones received their first ship contract in 1853 for an iron side-wheel steamer. This yard constructed hundreds of vessels, including the steel-hulled racing yacht the *Volunteer,* who defeated the English yacht the *Thistle* in the 1887 International Cup Races.

Early in the nineteenth century the smaller towns along the river, such as Milford and Milton, also engaged in shipbuilding. Shipyards in Milton, for example, began April 16, 1737, with the building of the shallop *Broadkill* and ended with the construction of the *Wildcat,* an iron fishing vessel, on November 8, 1915. During this period they built 271 vessels. Sail powered 263 of these and included both sloops and schooners. This activity peaked between 1861 and 1880.

In Milford, along the Mispillion River, 286 vessels were constructed between 1761 and 1917. Fifty-nine were built before 1841 and these were mostly sloops. Schooners predominated over the next seventy-seven years. A total of 218 ships were built in Milford between 1841 and 1900.

Trade was also of major importance. Whaling ships operated from Wilmington and Philadelphia and these cities had almost all the coffee trade. Gross receipts from customs duties in 1790 show that Philadelphia handled about one-fourth of the country's imports, but its share of these had dropped to 15 percent by 1825. Boston and New York accounted for

one-third and one-fifth of the foreign trade both in 1795 and also in 1810. However, Boston's share of the coastal tonnage fell from half to less than a third during those years while New York's portion grew from less than a tenth to over a quarter. The inference is that while Boston held its own, New York was growing at the expense of Philadelphia, Baltimore and the other smaller ports. Charleston had 46,000 tons of shipping in 1790 but this had fallen to only 8,000 tons by 1840. During this period Newport also lost shipping to Baltimore, perhaps because of the northern city's more central location.

In the early nineteenth century, as the country's internal economy grew, the relative importance of foreign trade declined. Still, by 1825 the four northern ports accounted for 55 percent of the nation's exports and over 80 percent of the import trade.

When the Chesapeake and Delaware Canal was completed in 1829, the Delaware River—with the port cities of Philadelphia, Wilmington, Camden and Baltimore—was one of the main shipping routes in the country. It continued to be important throughout the nineteenth century and by the beginning of the twentieth century had the greatest tonnage of commercial traffic in the country. The ports of Philadelphia and Wilmington along with Bordentown, Bristol, Burlington, Camden, Chester, Florence, Marcus Hook and Trenton had a tonnage that increased from 24 million tons to 27 million between 1903 and 1913.

Because maritime trade was such an important part of life in the colonies and the new country, it soon became evident that the safety of this commerce was important and various aids to navigation started to appear. One of the first of these was the Boston lighthouse established in 1716, although it is reported that there had been a kettle of burning tar maintained on Point Allerton Hill near Boston since 1696. The eighteenth-century records say little about other navigational aids. Amy Marshall points out that there were some cask buoys in the Delaware River recorded in 1767 and some spar buoys in Boston Harbor listed in 1780.

After considerable discussion, the maritime interests in Philadelphia held a lottery to acquire the funds necessary to build a lighthouse on Cape Henlopen at the entrance to the Delaware Bay. Crude whale-oil lamps had been privately maintained at this important location since 1725. The lighthouse was completed with a temporary light in 1765 and became an official station in 1767. This was the sixth lighthouse built in the New World. The importance of lighthouses is indicated by Pennsylvania Statutes at Large 1771, which describes punishment for their destruction: "a fine of 1,000 pounds, three years imprisonment, and 39 lashes of the whip well laid on."

After the 1789 Congressional legislation, the building and placement of navigational aids began in earnest. There were, however, places where it was not possible to build a lighthouse, either because of the conditions on the sea bottom or the distance from shore. Lightships, or floating lighthouses, then became an essential part of the government's commitment to safe navigation on the country's waterways.

BRANDYWINE SHOAL, DELAWARE

About twelve miles north of the entrance to the Delaware Bay there is an obstruction about three miles long and a half-mile wide known as Brandywine Shoal. Modern charts show that it has a depth of between four and five feet, making it a dangerous area for navigation. It is thought that unmarked beacon boats, small vessels with a mast to which daymarks were attached, and other primitive aids to navigation were here in the late eighteenth century along with similar devices at other nearby shoals.

On May 29, 1823, on behalf of the federal government, Jonathan Thompson, then superintendent of lighthouses in New York, contracted with Henry Ekford, a New York shipbuilder, for the construction of three vessels to be used as lightships. The largest, at three hundred tons, was for Diamond Shoals at Cape Hatteras and the two smaller ships, at one hundred tons each, were for the Delaware River. The smaller two were seventy-two feet in length, built of oak and with pine decks. Two masts carried the lanterns. Cabins for sleeping six to eight men were included. The price for this fleet was $43,000.

The first of the seventy-two-foot schooners was placed approximately one mile west of Brandywine Shoal in 1823. The vessel was equipped with two oil lamps, each with twelve wicks showing a fixed white light forty-two feet up the foremast and forty-five feet up the main mast. For fog, the ship was equipped with a 450-pound hand-operated bell.

This station was superseded in 1850 by the Brandywine Shoal light, located one mile east of the former lightship and in six feet of water on the southern tip of the shoal. This was the first lighthouse built in America on screw piles. A screw-pile lighthouse is a lightweight wooden tower on iron stilts, the legs of which are tipped with corkscrew-like flanges. These large augers, when turned, bore down into the sand. Several of these pilings provided a base strong enough to support both the light and the keeper's house. This new type of lighthouse was dependent upon the development of wrought-iron columns for the legs and cast iron for the screw-like flanges. This technology permitted the construction of lighthouses on sites too soft to support the weight of a heavy tower. Alexander Mitchell patented the

Lightship *N* placed in the Delaware River in 1823. *Courtesy of James W. Claflin.*

design of screw-pile lighthouse in 1838. James Walker built the first one, the Maplin Sands lighthouse, in 1841. It was located off the east coast of England.

Major Hartman Bache directed the building of the Delaware River structure. He was assisted by Lieutenant George Meade. While Bache went on to become superintendent of lights on the West Coast, Meade is probably better known. He was an 1835 graduate of West Point and, as a member of the Army Corps of Topographical Engineers, went on to build and improve lighthouses from New Jersey to Florida before he became famous at the Battle of Gettysburg.

The success of this construction encouraged the Lighthouse Board to use the technology in many other places in shallow and slow-moving water where the bottom was too soft to support a traditional building. Within a few decades, perhaps as many as one hundred screw-pile lighthouses were built throughout the United States, principally in the Carolina sounds, the Chesapeake Bay and Florida.

UPPER MIDDLE/CROSS LEDGE, DELAWARE

Located about fourteen miles upriver from Brandywine Shoal, the Upper Middle Shoal is about two miles long and a quarter-mile wide with three

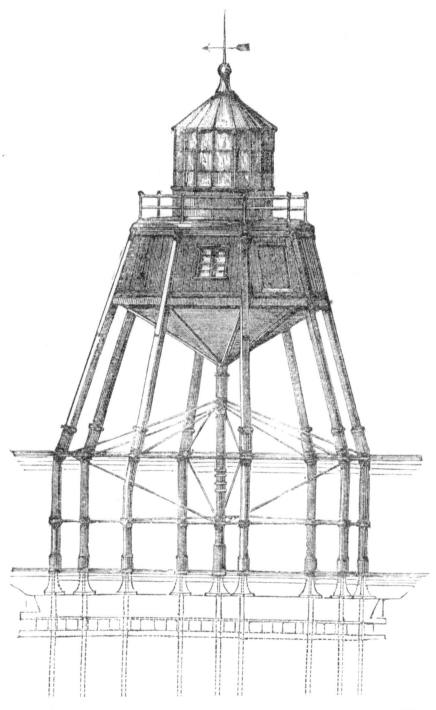

The first screw-pile lighthouse was built in 1841 at Maplin Sands. England. *Courtesy of the author.*

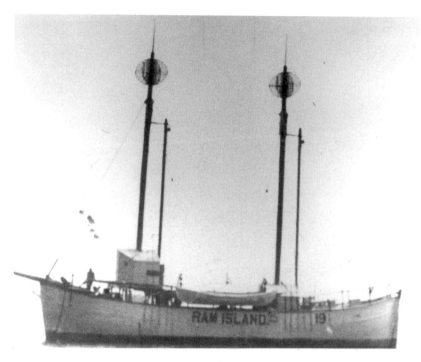

LV *19* after it was rebuilt in 1876. *Courtesy of James W. Claflin.*

to eight feet of water indicated on a modern chart. Today it is known as Cross Ledge.

Two vessels are listed as having covered this station, but there is evidence that the second might have been a rebuilding and enlargement of the first. The second vessel that Henry Eckford built in 1823 for the Delaware River was identical to the one on Brandywine Shoal. It was also a seventy-two-foot wooden schooner. The records indicate that this vessel was probably rebuilt in 1845 and again in 1854. In 1848 a second oil lamp with twelve wicks was added, so the vessel was probably a two-mast schooner. During the winter, river ice caused the vessel to be moved off station for periods of time, with its absence causing problems for ships traveling up and down the Delaware. In 1867 the lightship *Upper Middle #2* became LV *19* when the Lighthouse Board directed that lightships be numbered.

Sadly, on October 29, 1873, three crewmembers drowned while attempting passage from Little Creek Landing in Delaware back to the ship.

FOURTEEN FOOT BANK, DELAWARE

In December 1875, the Cross Ledge lighthouse, located about three-quarters of a mile north, became active. After extensive rebuilding in 1876

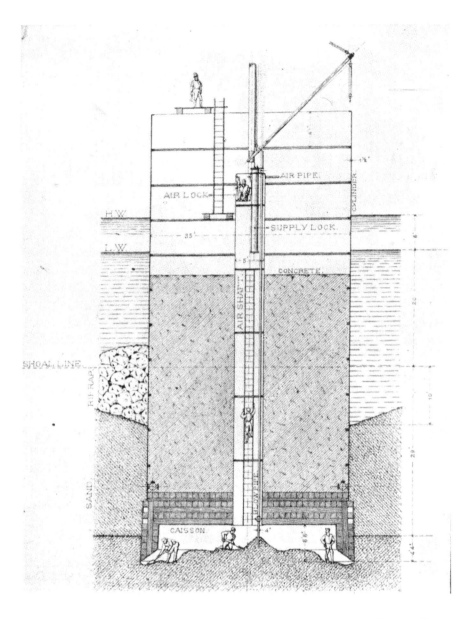

A cutaway of a typical pneumatic caisson such as used in 1887 to build the Fourteen Foot Bank lighthouse in the Delaware River. *Courtesy of the author.*

the lightship LV *19* was moved about nine miles to the south to mark a shoal lying on the western side of the shipping channel. This new lightship station was named Fourteen Foot Bank. It operated for ten years until the Fourteen Foot Bank lighthouse was constructed. Again technology worked to replace the lightship.

The first lighthouse built in the sea and distant from land was the *Rothersand*, built in twenty feet of water about ten miles off the German coast. It was completed in 1885. Two years later, in 1887, the first American lighthouse constructed using a pneumatic process was built on a sand bottom in twenty feet of water. A forty-square-foot timber working chamber that had a cutting edge seven feet deep was built in Lewes, Delaware.

On this was placed an iron cylinder thirty-five feet in diameter and eighteen feet high built of one-and-a-half-inch-thick cast-iron plates bolted together by their flanges. This was towed to the site and sunk into position. Here the cylinder was sealed and compressed air kept the water out while shifts of eight men each worked three shifts a day digging out the sand. The caisson sank one or two feet a day until it reached a depth of thirty-three feet below the surface of the shoal. The cylinder was built up until it was seventy-three feet high and then filled in with concrete. The lighthouse was erected on this base.

These three lightships that were in service for sixty-three years, 1823 to 1886, are the only ones reported in official documents. Several researchers have indicated that there may have been several more—probably privately owned and operated by local shipping interests. In all cases the winter ice, which caused the vessels to be removed from their stations, contributed to their unreliability, often when most needed. This led to the construction of more permanent lighthouse structures. From 1767 to the present there have been 278 lightships, lighthouses, light towers and range lights established in the Delaware River and its bay. This number includes only those under the authority of the U.S. Lighthouse Service and the U.S Coast Guard and does not include any private aids. Today 189 of these aids are active.

Chapter 2

Inside Lightships—Chesapeake Bay

A little more than 50 miles to the west and with its opening about 150 miles south of the Delaware is another major estuary of the Mid-Atlantic Coast, the Chesapeake Bay. Extending 200 miles from its Atlantic Ocean mouth to where it meets the Susquehanna River, it covers an area of about 4,000 square miles, touching 8,000 miles of coastline almost equally divided between Maryland and Virginia. Baltimore is the major commercial city on the bay, but there are many protected harbors on both the eastern and western shores.

These harbors provided an easy outlet for the exchange of local products, agricultural and manufactured. Crisfield, on the lower eastern shore, was a port of entry in the customs district and a major oyster shipping spot. Salisbury, on the Nanticoke River, enjoyed a large trade in grain, fruit, textile products and lumber. On the Choptank River, Cambridge shipped lumber, fish and oysters. On the western shore, Annapolis was a port of entry. Havre de Grace traded in lumber and fish. Norfolk, Virginia, which was settled in 1680, had little importance for a number of years, as the surrounding lands were not productive for tobacco, the region's leading product. However, as the years went by, the magnificent harbors of Norfolk, Hampton, Portsmouth and Newport News enabled this area to become the major Chesapeake port. In the early nineteenth century there was a booming trade with the West Indies, as Norfolk served as a collecting point for the transshipment of goods flowing both ways. When the railroad developed, the port gained even more importance.

Shipbuilding flourished in the bay and its tributaries, especially for the smaller craft needed to navigate the shallow waters. The raw materials— cedar, oak and pine—together with naval stores, were abundant and many shipyards existed. These yards extended up the rivers on each side of the bay to Alexandria and Washington, D.C., on the west and as far north as Denton, Maryland, on the Choptank River and Seaford, Delaware, on the Nanticoke River.

The small town of Bethel, Delaware, on the Nanticoke River was noted for the sailing rams built there toward the end of the eighteenth century. These large, three-mast vessels were made to carry merchandise but were also narrow enough to traverse the Chesapeake and Delaware Canal. One of the rams, the *Edwin and Maude,* remained in commercial service until the mid-1940s. It has been renamed the *Victory Chimes* and is part of the windjammer fleet in Maine. Seen sailing past the Pemaquid Point lighthouse on the back of the Maine quarter, it is part of the U.S. Mint Quarters Program.

As the vessels became larger and steamboats were added to the mix, the number of shipyards declined, while those remaining became larger.

Baltimore had a very shallow harbor, only allowing deep-draft vessels safe anchorage about a mile from Fells Point, while those with drafts less than six feet could travel the additional distance to the city's main docks. By the time Baltimore was able to successfully dredge a channel, it had lost ground to other ports on the eastern seaboard, notably New York and Philadelphia. Despite these difficulties, vessels still came because of the availability of foodstuffs and manufactured goods that were produced in the hinterlands.

The British Blockade in 1813 caused external trade in the bay to come to a standstill and, coupled with several depressions, kept the Baltimore area from becoming as prominent as it might have been. Another factor was that the local shipbuilders did not seem to incorporate new technology and designs into the vessels that they constructed. The Baltimore clipper was a successful model for privateering activities during the War of 1812 and during some of the Hispanic wars of independence. It was also good for the coffee and slave trade. These ships were, however, too small in cargo-carrying capacity to compete successfully for the Atlantic and China trade. The new clipper ships being built in the northern shipyards were much larger and of a different design. The Chesapeake shipyards continued to build traditional craft, including skipjacks and sailing rams for the local market, into the twentieth century.

Throughout the period, Baltimore grew as the country grew. It remained an important port, ranking fifth in imports and seventh in exports in 1860. By 1914 it ranked ninth in imports and eighth in exports.

To provide for safe navigation, sixteen lightships were positioned in the Chesapeake Bay between 1820 and 1965. Most of these were in Virginia's waters, but five served in the Maryland portion of the bay. Many of these stations had their service interrupted between 1861 and 1865 because of actions taken during the Civil War.

It was in Virginia that the first American lightship appeared. Congress appropriated the funds and awarded the contract to James Poole (sometimes

recorded as John Pool) of Hampton, Virginia, on September 2, 1819. He built a small wooden schooner of seventy tons. It had a wooden hull sheathed with copper, berths for four men, a galley and a yawl boat with davits. Stationed in 1820, the ship served as an aid to navigation at the northern edge of a shoal extending out from Willoughby's Spit, inside the entrance to the Chesapeake Bay. This position was about thirteen very exposed miles from the Atlantic Ocean.

CRANEY ISLAND, VIRGINIA

The vagaries of weather and sea conditions soon caused Poole's vessel to be moved to a safer location off Craney Island in the Elizabeth River. Here it guided the approach to the Norfolk and Portsmouth harbors. The Poole-built vessel is the only ship to serve here, remaining for thirty-nine years until the station was closed in 1859.

WILLOUGHBY'S SPIT, VIRGINIA

Although the first lightship on Willoughby's Spit did not survive the exposed location, the station was reestablished in 1821 when a new light vessel arrived. The replacement ship covered this station for twenty-six years until 1847. We know very little about this vessel. It is reported to have been built in 1821, weighing 120 tons and with a wood hull.

After the Mexican War, a former revenue cutter, the *Spencer*, was acquired and served from 1847 until 1867. This was a steam-driven vessel built in 1844. It was fitted with an Ericson screw propeller. The vessel turned out to be a most unsatisfactory craft for the Revenue Service's purpose and this was probably the reason it was available to the Lighthouse Service, which used boats that did not have to go anywhere. The Revenue Service built sailing vessels, or side-wheelers, for the next several years.

A wooden schooner-rigged sailing vessel, LV *21*, about seventy-eight feet in length and 150 tons, assumed the station in 1867. It carried two lanterns, each with eight lard-oil lamps and a hand-operated bell and horn. It was relieved the next year and continued in service at a number of other stations. Its replacement was LV *23*, a ninety-four-foot schooner that was purchased by the government and converted for use as a lightship in 1862. It seemed to carry the same equipment as its predecessor and was the last lightship to serve at Willoughby's Spit before the station was discontinued in 1872. The construction of the Thimble Shoal lighthouse made the lightship station redundant. This vessel, however, continued in service at several northern stations before being retired at age sixty-eight in 1925.

WOLF TRAP, VIRGINIA

Upstream is the Wolf Trap Shoal on the western side of the bay, where a lightship was placed in 1821 to serve as a guide for those vessels passing the shoal. Early records indicate that two craft were anchored here in the early to mid-1800s. The first, built in 1819, was part of the same appropriation for the ship James Poole built but there is no other information about this vessel. The second was the same eighty-one-foot wooden boat used at the York Spit station.

The station was vacant from 1861 until 1864 as Confederate forces burned and sank the second lightship. From 1864 until 1870, LV 22, receiving its numerical designation in 1867, served this post. A screw-pile lighthouse took over the duty in 1870, but it was destroyed by ice during the winter of 1892.

Maritime safety required a lightship to stand by while a new lighthouse was constructed. LV 46 was assigned this duty. This ship was built for Cape Charles but only served there for three years. The vessel was then assigned to Bush Bluff, near Norfolk, where it anchored for two years before moving along to Wolf Trap. On August 28, 1893, a boiler explosion, which killed the engineer and a seaman, damaged the ship, necessitating its withdrawal for repairs. The schooner the *Drift*, later to become LV 97, covered the station until March 16, 1884, when LV 46 returned to its post. The new lighthouse was completed in 1894, and remains an active aid to navigation today.

SMITH POINT, VIRGINIA

Smith Point was another station with multiple purposes. On the west side of Chesapeake Bay, it marks the south side of the entrance to the Potomac River. About one hundred nautical miles up this river are the cities of Alexandria, Virginia, and Washington, D.C. Both were busy ports, with Washington reporting in 1881 that 2,889 vessels visited the docks. These ships carried, among other things, 36 million feet of lumber, 389,000 bushels of oysters, 5,000 watermelons and 128 tons of ice imported from Maine.

Additionally, the Smith Point lightship guarded a shoal and served as a waypoint for the north and south bay traffic. Starting in 1821 the records show a 120-ton vessel with a wood hull at this location. Navy lieutenant William D. Porter, when inspecting the vessel in 1838, found that the captain and all the crew had been absent for a week. The boat had been left in the charge of a fourteen-year-old boy who was not strong enough to raise the lantern which had been left at half-mast. In 1861 Confederate forces captured and removed this craft.

In 1862, LV 23, complete with a military guard, replaced the previous ship. This schooner, at ninety-four feet, was converted for lightship service.

It carried the familiar two lanterns, each with eight oil lamps and a hand-operated bell. Other than being away from the station for several days while caught in ice, drifting and being towed in, the vessel served here until a lighthouse was completed in 1868.

In 1895 this Smith Point lighthouse was also carried away by ice and starting on February 14, 1895, LV 46 had to cover the station until the replacement lighthouse was completed in 1897. This vessel went on to serve at the Overfalls Shoal at the entrance to the Delaware Bay and then at the Tail of the Horseshoe in Virginia before being retired in 1922.

UPPER CEDAR POINT, MARYLAND

The Potomac River was a major shipping route in the eighteenth century and lightships aided navigation. The Upper Cedar Point station was established in 1821 at a sharp bend near the mouth of the Tobacco River, about three miles north of today's Highway 301 bridge. Three small wooden ships covered this station until the final ship was captured and removed by Confederate forces in 1861. After the Civil War, another LV 21—built in 1863, in New Bedford, Massachusetts, by Steven Andrews as part of a contract for three vessels—took up the post. This was a seventy-eight-foot, 150-ton schooner. Three years later, in 1867, the Upper Cedar Point lighthouse was completed and the ship was reassigned to Willoughby's Spit.

LOWER CEDAR POINT, MARYLAND

The Lower Cedar Point station was positioned in 1825 just south of today's highway bridge location. A 72-ton wooden vessel occupied this post until the ship was captured and removed by Confederate forces in 1861. After the Civil War, LV 24 served on the station until the lighthouse was completed in 1867. This was the first assignment for this seventy-seven-foot, 115-ton wooden sailing ship also built by Steven Andrews. Its equipment consisted of two lanterns, each with eight oil lamps and a hand-operated bell. It left this station for York Spit and other subsequent assignments.

HOOPER STRAIT, MARYLAND

Just north of Bloodsworth Island and south of Hooper Island is a strait leading east into Tangier Sound, which leads to the Honga, Nanticoke and Wicomico Rivers, as well as to some points south of Maryland's eastern shore. A large portion of the region's products reached Baltimore by this route. William Price of Baltimore built a sixty-one-foot schooner, which carried a single lantern with an oil lamp having twelve wicks. It also had a hand-operated bell and a horn. Placed in the strait in 1827, the condition of the vessel deteriorated over the years and a new ship was commissioned

in 1845. This was a seventy-two-ton vessel, LV *25*, built for this post by William Easby of Alexandria, Virginia. It was sixty-nine feet in length and schooner-rigged. The masts, lantern and other equipment from the first lightship were transferred to the new one, which took up the station in September 1846. It served here, including during the Civil War, until the Hooper Island lighthouse was activated in 1867. The lightship went on relief and other duties for the next eighteen years.

WINDMILL POINT, VIRGINIA

Windmill Shoal extends southeast from the same-named point for about 4.5 miles into the Chesapeake Bay. A lightship station was established here in 1834, not only to mark the shoal, but also to serve as a guide to the Rappahannock River entrance. While we know that a vessel was stationed here for about thirty years and was captured and removed by Confederate forces in 1861, no information is available concerning the ship's characteristics. The station was probably vacant between 1861 and 1867.

The records show LV *21* was the next ship stationed here, placed on August 17, 1867. It had been working as a relief vessel out of Virginia, but was moved here on a temporary assignment until the lighthouse was completed in 1869. This lightship, which had served two previous stations in the Chesapeake Bay, went on to cover two more stations farther south. The vessel only survived a total of seventeen years before it was determined that it was not worth the needed repairs and was sold for $200 at a public auction on January 7, 1880.

BOWLERS ROCK, VIRGINIA

Thirty-four miles up the Rappahannock River, marking a rock on the side of the channel, sat a small wooden-hulled lightship installed at Bowlers Rock in 1835. An 1838 inspection report said that the vessel was too small for the illuminating apparatus that it carried. Confederate forces destroyed this vessel in 1861. After the war, LV *28* was placed on this station until it was closed in 1868. This again was a small, eighty-two-foot wooden ship of eighty-three tons. It carried a single lantern with eight oil lamps and had a hand-operated bell for its fog signal. After its service at Bowlers Rock it was sent to the Gulf of Mexico, where it remained in service until it was retired in 1906.

YORK SPIT, VIRGINIA

About thirteen miles from the ocean, another dangerous shoal extends eight miles into the Chesapeake Bay. Passage along the shore south of this shoal

York Spit, a typical 1870s screw-pile lighthouse as found in the Chesapeake Bay. *Courtesy of the United States Coast Guard.*

into the York River has plenty of deep water but this is not so if a more northern course is taken. A lightship was stationed just off the southeast end of the shoal in 1855.

Sketchy records indicate that an eighty-one-foot wooden ship of about 150 tons first occupied the York Spit station. This vessel was also used at the Wolf Trap station. In 1861 it is reported that Confederate forces captured and removed this vessel, leaving the station unmarked. The War Department requested it be reestablished and this was done in 1863. A vessel built at Philadelphia in 1846 was assigned the number LV *22* in 1867 but was subsequently renumbered LV *12(II)* in 1871. The ship was a seventy-two-foot wooden schooner of 159 tons. It occupied the position during part of the Civil War. This vessel carried a single lantern, with eight lard-oil lamps and reflectors and also a hand-operated bell. But again the post was discontinued on August 2, 1864. Three years later in 1867, the station was finally reestablished with the yellow-hulled LV *24* as its occupant. This was another small wooden schooner previously posted to the Lower Cedar Point station, following which it served as a relief vessel before being posted for a year to the Winter Quarter station.

A screw-pile lighthouse built at York River in 1870 replaced the lightship. After almost one hundred years this light was exchanged for a contemporary structure placed on the same foundation in 1960.

JANES ISLAND, MARYLAND

On the east side of the Chesapeake Bay, between Smith Island and the eastern shore port of Crisfield, a lightship station was maintained for fourteen years, starting in 1853. This station marked the entrance to the Little Annamessex River and was a guide to Tangier Sound traffic. The light lists for the appropriate years confirm that a vessel was assigned here; however there are no records identifying the specific ship. The ship was seventy-six feet long and had black letters on a cream-colored hull. Although the lightship was not damaged during the Civil War, the position was discontinued when the Janes Island lighthouse was activated in 1867.

CHOPTANK RIVER, MARYLAND

The use of LV *25* during the 1870–1871 period was a temporary assignment while the new lighthouse was being built. This location marked the entrance to the Choptank River at its junction with the Tred-Avon River and was the farthest position up the Chesapeake Bay that lightships were used. After its service here, LV *25* was towed north, where it served at several posts before being sold for $101.02 at a public auction in New London, Connecticut, on January 1, 1885.

Bush Bluff, Virginia

In the Elizabeth River, about a mile and a half north of Craney Island, a station was established in 1891, thirty-two years after the Craney Island station was discontinued. Bush Bluff served not only to mark the shoal but also as a guide to the approaches to Norfolk and Portsmouth Harbors. For the first few years of operation several vessels, including LV *46*, shared the duty. LV *97* covered the station between 1895 and 1918. This vessel was formerly the Coast and Geodetic Survey schooner, *Drift*. The original eight-oil-lamp lantern was replaced in 1913 with a 30-candlepower incandescent lamp powered by batteries that were taken ashore to be recharged. It is possible that this was the first light of this type in use, but a lens lantern using oil gas for fuel replaced it in 1915. LV *97* also spent time at the Wolf Trap station. In 1918 the ship was replaced by a buoy.

Tail of the Horseshoe, Virginia

The Horseshoe Shoal extends about three miles southeast from Hampton on the Virginia shore, where modern charts show its depth as eighteen feet or less. The Tail of the Horseshoe extends another five miles in the same direction, with its depth indicated as between eighteen and thirty feet. In 1900 a lightship was placed at the eastern end of this shoal, about three miles east of the current bridge-tunnel roadway. This vessel served to mark the junction of the Thimble Shoal channel into the Elizabeth River and the northbound Chesapeake Bay channel as well as to warn about the extensive shoaling in the area. During 1900, the first year this station was active, LV *71* attended the post. LV *46* covered the other twenty-one years of activity after a short stint establishing the Overfalls station. In 1920, during its stay at the Tail of the Horseshoe, it was equipped with a submarine bell and radio.

Thirty Five Foot Channel, Virginia

About three miles west of the current bridge-tunnel roadway was the Thirty Five Foot Channel station, marking the junction for the westbound York River entrance and the northbound main Chesapeake channel. Starting in 1908, and for all of its ten years of operation, this position was covered by LV *45*, coming off twenty years at the Winter Quarter Shoal following a survey which found it better suited for a less exposed station. By this time the vessel carried a compressed-air fog signal powered by two 3.5-horsepower oil engines and a submarine bell. Surviving two collisions with schooners and a gale, this ship caught fire in 1918 while in a shipyard and was so badly damaged that she was condemned and sold on April 27, 1920. A buoy marked the station until it, too, was discontinued in 1919.

Chapter 3

Inside Lightships—North Carolina Sounds

Moving south along the North Carolina coast, there were eleven early inside lightship stations, all of which had been deactivated by 1870—probably a result of Civil War actions. In 1861 the Lighthouse Board reported, "All the light-vessels from Cape Henry southward…have been removed and sunk or destroyed by the insurgents."

Three of these stations were in Albermarle Sound and seven in Pamlico Sound. Both of these sounds are shallow, sometimes being described as half water and half ground. The shoals located in these sounds are constantly on the move. This makes navigation difficult for all but those very few watermen with precise local knowledge. Despite the difficulties, the region became an important spot for commerce.

The Dismal Swamp Canal connects the Elizabeth River in Virginia and the Pasquotank River in North Carolina. It is the oldest continually operating canal in the country. Governor Patrick Henry of Virginia proposed the construction of the canal in 1784 and George Washington was one of the early investors. After much difficulty, it opened for business in 1805 and by 1820 had become an important part of the commercial traffic between Virginia and North Carolina. Today it is part of the Intracoastal Waterway and used by about two thousand boats each year. This connection allowed Elizabeth City, located at the narrows of the Pasquotank River, approximately twelve nautical miles from the Albemarle Sound, to develop a significant commercial commerce. By the early 1800s a vigorous trade with the West Indies was established and about a hundred years later this freshwater landlocked harbor on the Pasquotank River rivaled Baltimore as an important East Coast port.

WADE POINT SHOAL, NORTH CAROLINA

Wade Point Shoal station, near Elizabeth City, was located in the sound at the west side of the entrance to the Pasquotank River and served to guide

ships into the river. The only vessel listed for this station is a forty-one-ton wood-hull vessel carrying an oil lamp. Activated in 1826, it operated for twenty-nine years until it was replaced in 1855 by the Pasquotank River lighthouse, located about two miles northeast of the former lightship station.

At the head of the Albemarle Sound, where the Roanoke and Chowan Rivers enter, the city of Edenton was established in 1715 as the first permanent settlement in North Carolina. This became the focal point of civilization in the province, the capital of the colony in 1728 and the home of the royal governors. It was a regular port for hundreds of ships carrying slaves, food and agricultural products, which supported the plantation economy of the region. It was a colonial center of commerce.

Not far from Edenton was Plymouth, also an important port where water traffic played a major role in its development. Flatboats came down the creeks and rivers loaded with goods and produce to be shipped out on sailing vessels. Early in the 1800s Plymouth was one of six main ports in North Carolina. In 1790 the United States Congress established Plymouth as a customs port. Schooners bound for the West Indies sailed from the port heavily loaded with hogsheads of tobacco, barrels of tar, pitch and turpentine, masts and spars, corn and rice. This activity seemed to justify the placement of lightships to help sailors navigate the sound.

ROANOKE RIVER, NORTH CAROLINA

In 1835, a lightship was placed near the town of Edenton, marking the entrance to the Roanoke River channel. This small, twelve-ton vessel, with a wood hull and oil lamp, was reported to be assigned to this station until it was eliminated by Confederate forces in 1861. It is uncertain, but possible, that this ship was later restored and served on the station between 1863 and 1866, when the Roanoke River channel entrance light, about two miles southeast from the lightship station, was completed.

ROANOKE ISLAND, NORTH CAROLINA

A third interior lightship was stationed at the junction of Albermarle Sound and Croatan Sound, where there is a course change for the inland passage south to Pamlico Sound. The seventy-two-ton wood-hull vessel at Roanoke Island was replaced in 1861 by the Croatan lighthouse and then by the Croatan Sound Approach Light #3, about three and a half miles northwest of the former lightship station.

There was also considerable ship traffic on Pamlico Sound in the late seventeenth and early eighteenth centuries. Waterways were the main avenues for commerce and travel. Vessels were relatively small, interior

roadways sparse and the railroads had not yet arrived. In the northwest region of the sound, the Pamlico River leads to Washington, North Carolina, the first city in America to be named for General George Washington. The city was a regional shipping center because of its strategic location at the junction of inland and coastal waters.

Farther south, the Neuse is the second significant river leading into Pamlico Sound. At this junction is the city of New Bern that was settled by Swiss and German adventurers beginning in 1710. Royal Governor William Tryon made this seaport the colonial capital in 1780. Today his restored eighteenth-century residence still remains and is open to the public. This city was also a major port and trading center in the 1800s.

The entire sound is protected by many barrier islands known as the Outer Banks. These sandbar-type islands are in constant motion and passageways move about. Often deepwater vessels would not attempt passage but rather would anchor on the ocean side and transport their cargo across the islands to be loaded aboard shallow draft vessels for use in Pamlico Sound. Portsmouth Village, located on the barrier island just south of what is now the Ocracoke Inlet, was one of these locations. In the early 1900s, following a hurricane, a channel opened on the southern end of Ocracoke Island and allowed the ocean vessels passage. The purpose of the settlement later diminished and the town vanished.

The lightships placed in Pamlico Sound during the second quarter of the nineteenth century all marked shifting sandy shoals in the eastern section of the sound.

LONG SHOAL, NORTH CAROLINA

In the northern part of the sound a lightship served as a guide for passing Long Shoal. This lightship station also was the mark for the inside passages to and from Albemarle Sound to the north. The first ship to mark this station in 1825 was 145 tons and built with a wooden hull. The ship's lamps were illuminated by oil and it had only a hand bell. It also carried a horn.

It was removed, sunk or destroyed by Confederate forces in 1861. Another vessel was placed on the station for three years, 1864 to 1867, before being replaced by the Long Shoal light. This light is located about four miles northwest of the lightship station.

OCRACOKE CHANNEL, NORTH CAROLINA

Ocracoke, a barrier island, is the home of one of the significant Outer Banks lighthouses. Built in 1823, the Ocracoke lighthouse is North Carolina's oldest active light and the second oldest continuously operating lighthouse on the East Coast of the United States. For seven years—1852

through 1859—a lightship was used to guide the passage through the inlet off the south end of this island. There is no description available of the vessel, which served here until it was replaced by buoyage marking these channels. The records do indicate the ship was illuminated by oil and had a hand-operated bell.

ROYAL SHOAL, NORTH CAROLINA

Very little information about the Royal Shoal station is available. The operation of the early lightships was inefficient and few records exist. The vessel assigned was illuminated by oil. It had only a hand bell until a horn was added in 1854. This station was occupied between 1826 and 1867.

HARBOR ISLAND, NORTH CAROLINA

The Harbor Island lightship station was located at the north end of Core Sound, a narrow band of water between the barrier islands and the mainland. A seventy-two-ton wood-hulled ship was positioned here in 1836. It was illuminated by oil and had only a hand-operated bell for eighteen years before a horn was added. It is possible that the original vessel was reconditioned for the final four years it served on this station. The station was replaced by the Harbor Island lighthouse in 1867, which has since been superseded by buoyage.

BRANT ISLAND SHOAL, NORTH CAROLINA

In 1831 a lightship was reported on the Brant Island Shoal station as a guide to the east-west traffic in Pamlico Sound. It was located fifteen miles due west of the Ocracoke lighthouse. This ship was illuminated by oil, carried a hand-operated bell and later had a horn installed. Willard Flint suggests that a second ship covered the station until 1863 when the Brant Island Shoal lighthouse became operational.

NINE FOOT SHOAL, NORTH CAROLINA

Approximately four miles northwest of the Ocracoke lighthouse, a seventy-ton wooden-hull vessel illuminated by oil with a hand-operated bell stood watch for thirty-two years, from 1827 through 1859. An inspector's report in 1838 found the decks injured because of the chopping of wood for cooking fuel. When this vessel was replaced by the Nine Foot Shoal lighthouse, since discontinued, it was reassigned to the Upper Cedar Point station in the Chesapeake Bay.

NEUSE RIVER, NORTH CAROLINA

The Neuse River station marked the entrance to the Neuse River and was operated for thirty-four years, between 1828 and 1862, when it was replaced

by a lighthouse that has since been discontinued. One vessel held the post. It was an 125-ton wooden-hull ship illuminated by oil that used a hand-operated bell for sound.

HORSESHOE SHOAL, NORTH CAROLINA

The last of the inside stations was located in the Cape Fear River, halfway between New York and Miami. Wilmington, North Carolina's principal deepwater port was especially important for naval stores, pine pitch, tar and resin. These were essential ingredients for the nautical world of the eighteenth century. The port is located several miles upriver and a lightship was located about four miles into the river, at the Horseshoe Shoal, to guard the shoal and assist vessels at a course change when making the Wilmington passage. This lightship station existed for nineteen years, from 1851 until 1870. Only one ship is listed at this station and all that is known about it is the lamps used oil as an illuminant. The records indicate that this station was "extinguished" for a period of time during the Civil War, but that did not hamper Wilmington from being the principal port for the blockade runners. These mariners, who had local knowledge about the inlets among the barrier islands and piloted faster steam vessels, were able to elude the sailboats used by the Union navy for the blockade. The station was ultimately replaced by buoyage and range lights.

Chapter 4

The Ships

A typical lightship of the mid- to late nineteenth century is shown in the picture of LV *1*. At the base of each main mast is the lantern house, a small building with a hinged roof. This allowed the lantern to be stored inside during the day where the crew could refill the fuel, clean the glass and trim the wicks. At the mast peaks, just under the lightning rods, are large latticework gratings that served as daymarks. These were displayed from the mast to indicate the vessel was anchored. With many sailing ships operating at the time, it was important to differentiate the lightship from the other vessels in the vicinity. When acetylene- and electric-powered lamps came into use, the old daymarks were eliminated, as the new lanterns were distinctive. The ship's color, usually red in modern times, was also a distinguishing feature, as was the station's name painted in large white letters on its side. A relief vessel would have the word "Relief" displayed. If the vessel was off station for any reason, a series of code flags with letters such as "P" and "C" were flown.

The small masts behind the larger ones are the "spencers," used to carry the sails that propelled the lightship. These vessels were not very efficient as sailing boats and were usually towed to their station. In 1891 three vessels in the Great Lakes were the first to be equipped with self-propulsion. In 1894 when LV *58* was built for the Nantucket station, it was equipped with a steam-screw propulsion system. A number of years passed before sail was completely phased out.

Some later-model ships had a funnel to carry off the fumes from the coal fires used to heat the boilers. The steam produced was not used for propulsion, but rather to power winches, to raise the lanterns and to operate fog signals. This was not very efficient because of the enormous amount of coal required to produce the steam and to keep it ready for use.

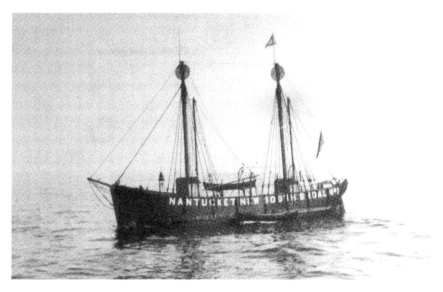

LV *1* as it sat on Nantucket/New South Shoal between 1856 and 1892. *Courtesy of James W. Claflin, Historic Nantucket Lightships.*

GROUND TACKLE

Keeping a lightship on station was always a challenge. At the bow of LV *1*, there is a relatively light anchor, probably having rode (anchor line) made of hemp. This material was not very strong and had a tendency to break when under heavy strain. Many lightships were driven off their station even in mild weather. In the early eighteenth century, the Five Fathom Bank ship was blown adrift or dragged off station eleven times. LV *69*, when first placed on Diamond Shoal, had a special mooring buoy that was supposed to relieve the direct strain on the anchor chain. This was found unsatisfactory when on February 26, 1898, the chain frayed and the buoy sunk.

The mushroom anchor weighing as much as 7,000 pounds became the standard. The style was developed by Robert Stevenson, an engineer known for the design and building of many famous Scottish lighthouses. Ultimately, the rode was made of heavy chain. The modern anchor chain, with its 1⅝-inch-diameter links, weighs about 26 pounds per foot. To be secure, the anchor chain was extended to six or more times the depth of the water—more in heavy weather and less when the weather was better. The lightship moved in a circle having a diameter of several hundred yards around its assigned location. If the vessel anchored in one hundred feet of water, at least six hundred feet of chain was required, resulting in a weight of 15,600 pounds, or about 8 tons. This amount of chain required careful placement to keep the lightship balanced when it was retrieved. In 1892, LV

52, which served at Fenwick Island Shoal, was one of four vessels built that year which were the first to have the hawsehole, where the anchor chain ran through the stem and aligned with the center of the vessel. This improved the holding capacity of the ground tackle.

Once anchored, the lightship would spend long periods of time at its station being relieved once every several years for routine maintenance.

TENDERS

To provide the necessary support services, other ships, called tenders, were also under the command of the Lighthouse Service. The Lighthouse Service acquired its first of these vessels in 1840. They were important because those serving on the remote lighthouses and the lightships could not have survived without this lifeline of support and maintenance. During the next seventeen years, other craft would be chartered or purchased to provide logistical support to the various lightships and lighthouses. These tenders also maintained other aids to navigation. It is from these duties that the name "tender" evolved. The tenders brought mail, pay, supplies, medical help and the relief crews. They towed early lightships to their station and returned them back to their stations after they were driven off by ice or storm.

Tenders also have their own stories. During the Civil War, the navy purchased a group of small boats and named them after flowers and plants. When these ships were acquired by the Lighthouse Service after the war, their names came with them and the tradition was continued. If you see a black-hulled vessel with a white superstructure named after a flower or plant, it is probably a U.S. Coast Guard buoy tender.

One such tender, the *Azalea*, was launched on June 25, 1891, and assigned to the Second Lighthouse District. In addition to performing its routine duties here, it also gained notice for several rescues of damaged lightships and their crews before it completed its service and was sold in 1933. The U.S. Navy then acquired it in 1942 and renamed it the USS *Christiana*. The ship served during World War II as a seaplane tender in the British West Indies. On February 25, 1946, it was sold to the Wilson Lines for use as a passenger cruise ship.

LIGHTS

By definition, a lightship should have a light. During the 165 years of American lightships, illumination technology went from being very primitive to being quite advanced. The development of the lighting device often followed changes in the type of fuel used for illumination.

The first modern lightship was the *Nore*, the ship placed in the Thames River in 1732. Its lanterns were lit with tallow candles and had limited

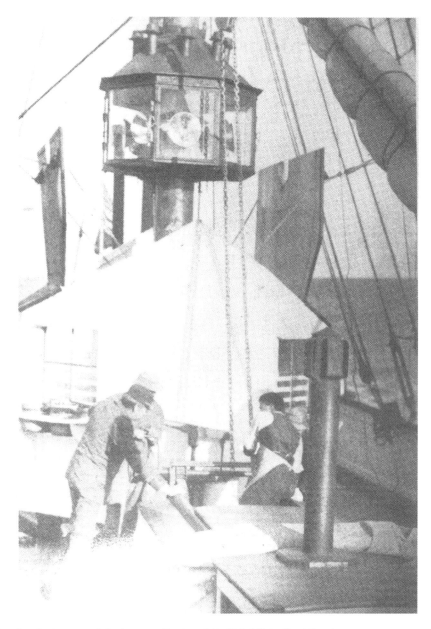

Cleaning the lamps and the lantern. *Courtesy of the United States Coast Guard.*

visibility. Nevertheless, it was a success in making the transit through that part of the river safer.

About a hundred years later, the early American lightships were equipped with various types of oil lamps burning, for the most part, whale oil. The early devices were covered oil-reservoir pans with many wicks protruding. These were mounted on gimbals and arranged on a platform five to eight feet in diameter that had glass panes and a roof. This contraption, which could weigh several tons, surrounded the mast up which it was raised each evening. During the day these lanterns were lowered to housing on the deck so that the crew could clean the glass, trim the wicks and refuel the lamps.

In 1781 a Swiss physicist, Aimé Argand, designed a new type of lamp that had a single wick and was able to produce as much light as several candles. This lamp had a hollow cylinder within the wick and a cylindrical glass chimney that allowed for a better airflow. A parabolic reflector was added to this lamp.

A modified version of this technology was patented by Winslow Lewis, a retired ship captain who had the ear of Stephen Pleasonton, the fifth auditor of the U.S. Treasury. Lewis's version placed several oil lamps with reflectors in each lantern. Although not well-made, these were adopted by the United States and installed in lightships and lighthouses until 1852. Lewis became modestly wealthy providing lightship and lighthouse services for the government at "the lowest bid price."

In 1822 Augustin Fresnel invented a lens system that enormously improved light visibility. Utilizing reflection and refraction, concentric rings of prisms bent the light into a narrow beam, making the light five times more powerful than the previously used reflector system. The United States was slow to adopt these devices. When finally accepted they were primarily used at lighthouses, but some versions eventually found their way to the lightship service.

As the fuels changed, so did the lamps. The early fuel was sperm-whale oil, but as this became more expensive—rising from 55¢ per gallon in 1840 to $2.25 per gallon in 1855—other fuels were sought. Colza oil was used at some stations. This oil was made from rapeseed, but the American production of this grain was not sufficient to supply the needed resource. Lard oil was tried but often this needed to be heated before it would work effectively. It was, therefore, more appropriate for a land-based lighthouse. Mineral oil or kerosene became important during the last part of the nineteenth century. This worked particularly well in the incandescent oil-vapor lights that had a mantle similar to the camping lanterns of today. This lamp greatly increased the candlepower without increasing fuel consumption. There was always the danger of fire with kerosene, so acetylene was developed as a

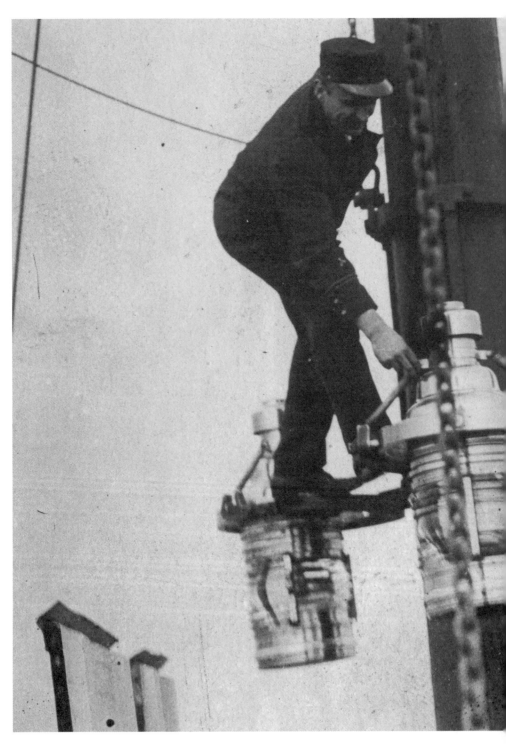

Cleaning the lamps after the advent of electricity. *Courtesy of the United States Coast Guard.*

safer fuel. Gas is generated when calcium carbide is met with water; this gas is highly flammable and burns brightly. It is the same gas used in a coalminer's lamp and it was used as an illuminant for lightships into the twentieth century.

In 1892 LV *51* was the first lightship built using electric illumination, although there had been some earlier experimentation with battery-operated lights. This ship had a cluster of four gimbaled lanterns, each fixed with a 100-candlepower incandescent lamp permanently fixed at each masthead. Through the lenses, the clusters had an equivalent of 4,000 candlepower. Electric power was provided by two engine-driven generators, one of which was on standby. Backup oil lamps were also installed in each lantern housing for use in the event of electrical failure. This was the only ship of the five built in 1892 to be so equipped.

Over the next several years other vessels were built with electric illumination but soon were converted to acetylene. The last vessel to have oil lamps as part of the original equipment was LV *93*, built in 1908. It was converted to a 375-mm electric lens lantern in 1930. The use of electricity meant that the lights could be switched on and off as needed, and that they burned clean so the lenses did not require the difficult daily cleaning to remove soot and other dirt that had accumulated. This also meant that the lanterns did not have to be raised and lowered on the mast each day.

The favorite illuminating apparatus during the later days of lightship service was the 375-mm duplex lens lantern, which produced about 15,000-candlepower and had a visible range of about thirteen miles.

After 1960, five lightships were equipped with clusters of twenty-four locomotive headlights, six on each face of a revolving lamp housing.

SOUND

Lightships and lighthouses had similar problems when faced with the challenge of providing audio signals in times of poor visibility. George Putnam, reporting around the early twentieth century, stated that there was an average of 332 hours of fog annually for the 116 stations. The San Francisco lightship holds the record, with more than 2,200 hours in one year. This is fog for 25 percent of the time, one day in each four. When storms or heavy fog occurred it was imperative that approaching vessels were warned of the dangerous surroundings that the lightships marked.

A fogbank descending over the water not only shuts off everything from sight but it also deadens sound. The atmosphere does many strange things to these signals, a result of the refraction and reflection of the sound waves. What is heard at six miles today may not be audible more than a mile away

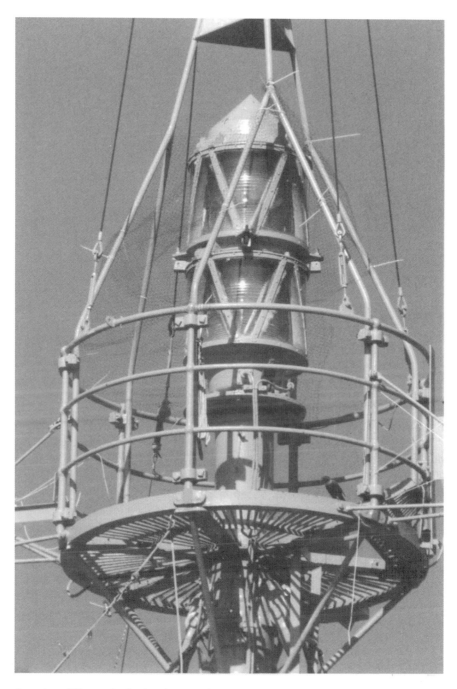

A modern 375-mm duplex lens lantern. *Courtesy of the author.*

tomorrow. Sound travels faster and farther with the wind, while against the wind the sound waves may be reflected upward, above the observer. Sound also travels faster in warm air than in cooler air.

A buoy would be moored about three miles from the lightship and when this was no longer visible the captain would order the fog signals into action.

A variety of experimental devices were tried, especially at lighthouses. These devices often required considerable space, equipment and, in some cases, fuel, making many of them impractical for lightships.

After some unsuccessful experiments with cannons, the early lightships used hand-operated bells for fog equipment. Just imagine a crewmember assigned to strike this bell every thirty seconds for the duration of his four-hour watch. It is said that one ship trained a dog to ring the bell. Later in the lightship era mechanical devices were invented to perform this chore.

Starting in 1875 steam, and later diesel, power plants were placed on the lightships. These power plants provided the energy to run pumps and the windlass that hauled the lanterns up the masts. These engines also provided steam and later compressed air to operate the fog signals, which were sirens, whistles, diaphragms or diaphones.

In 1895 two ships were equipped with the British Hornsby Ackroyd hot-bulb oil engine and compressors. All produced a sound superior to the hand-operated bell but these signals were still disturbed by the idiosyncrasies of the atmosphere. During periods of fog, the lightship crews were subject to the constant noise. In many cases ear protection was required to survive, but one crewmember reported being awakened when the signal shut down. After becoming accustomed to the noise, he had slept right through it. The British Lightship Service paid their crew extra for the time the fog signal was operating.

Sound travels farther and more reliably through water. Starting in 1906, sixty-four lightships were equipped with a new device known as a submarine bell. This apparatus is suspended twenty-five to thirty-five feet in the water and activated by compressed air. Each ship transmitted a distinctive pattern of sound so that receiving vessels would know which lightship was sending the signal as well as the direction from where it came. The Department of Commerce Buoy List in 1907 said, "Submarine bells have an effective range of audibility greater than a signal sounds in air, and a vessel equipped with receiving apparatus may determine the approximate bearing of the signal. These signals may also be heard on vessels not equipped with receiving apparatus by observers below the water line."

It took a number of years for these devices to be fully evaluated. Many merchant vessels did not install the equipment because of the expense

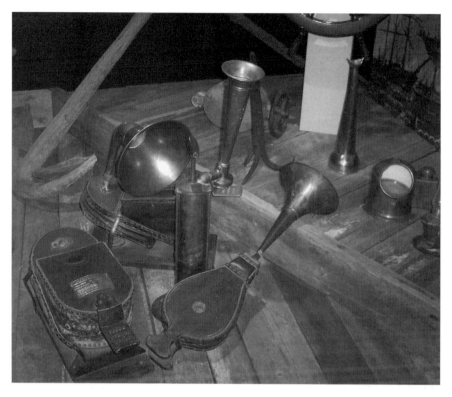

Some early types of sound apparatus. *Courtesy of the author.*

involved. It also was found that the currents had a major impact. In Buzzards Bay, Massachusetts, depending on the tide, a properly equipped ship could come within a half a mile of a lightship using this device and still not hear the signal. The devices were removed from lightships in the early 1930s.

Four vessels were equipped with the submarine oscillator, a more sophisticated version of this device. This was an improved way of signaling through the water, but one requiring specialized and expensive receiving equipment. Both for this reason, as well as the development of the radio beacon, these devices never found widespread use. Their descendents include the modern depth finders and fish finders.

RADIO

In 1896 Guglielmo Marconi first transmitted wireless signals between two islands off the Welsh Coast of England. His inventions had their beginnings with James Maxwell's work on electromagnetic waves in 1873. The big test on December 24, 1898, was between the South Foreland lighthouse, near

A typical hand-operated bell. *Courtesy of the author.*

Modern air diaphone fog signal apparatus. *Courtesy of the author.*

the city of Dover, and the *East Godwin* lightship, a distance of about fourteen miles. Development of this device progressed rapidly. Marconi established commercial service with France in 1899 and first transmitted a message across the Atlantic Ocean in 1901, with regular service operational the following year.

Radio communication was established experimentally with the Nantucket lightship in 1901 and in 1904 the U.S. Navy experimented with wireless equipment on LV *34*, then stationed off Charleston, South Carolina. By 1915 several of the most exposed coastal lightships were equipped with radio facilities. LV *94*, on Frying Pan Shoal, was equipped with radio when built in 1911.

The first quarter of the twentieth century was the highpoint of the lightship service, with about fifty ships on station. Between 1918 and 1920, thirty-four of these vessels were equipped with radios, although fourteen

were discontinued within four years. By the end of the 1920s almost every lightship was radio-equipped.

RADIO BEACONS

In 1917 Putnam indicated "experimental tests are in progress of the possible use of radio signals as fog signals, and of a vessel obtaining its bearings by radio." By the early 1920s, the radio fog signal, or beacon, had been developed. The early signals were activated only in periods of poor visibility, but with the advent of vacuum-tube transmitters, the beacons operated continuously. This device, an electronic equivalent of a lighthouse, allowed a vessel to home in on the direction from which the signal was sent. Unfortunately, sometimes the approaching vessel did not see or hear the lightship in time to alter course and collisions occurred. Forty-six lightships were equipped with this device between 1921 and 1938. As this technology developed, two improvements appeared. The first was to synchronize the radio-beacon signal with the lightship's fog signal so that distance could be estimated by the approaching vessel as the navigator noted the time difference between the radio signal and the foghorn blast. This time difference could be interpreted as a measure of distance. While it improved safety, it was far from perfect and accidents still occurred from time to time. The major breakthrough came when a group of radio-beacon signals were synchronized in a pattern. The approaching vessel then could use several of the signals to accurately determine their position by noting where two or more of the bearings intersected. A number of sequenced radio beacons provided distance-measuring ability during fog and other foul weather conditions. After World War II, lightships, as well as many other vessels, were equipped with radar gear that greatly reduced the need for radio direction beacons. A survey in 1987 indicated that the recreational boater is the primary user of the radio beacon and uses this as a homing device rather than to find position. Today this technology has been replaced by global positioning systems.

Chapter 5

Outside Lightships—New York Harbor

The stations so far described have been "inside" stations, those located in bays, rivers and sounds. The outside stations, those in the ocean, presented other challenges, including fog, shoals, stormy weather and being located far from shore. These elements compounded the boring and often dangerous life for the crew on these vessels.

NANTUCKET, MASSACHUSETTS

The Nantucket Shoals station marks the eastern entrance to New York Harbor. Established in 1854, it was the last American lightship station in existence when it was discontinued in 1983. The New England shipping interests urged the marking of New South Shoal, an extensive shoaling area about twenty miles southeast of Nantucket Island, so as to reduce the number of vessels and great amount of cargo lost in the area. As the years passed, the importance of Nantucket, New Bedford and other northern ports declined relative to New York Harbor, and the lightship station was moved five times, both to protect shipping from the shifting shoals and to reflect changes in the international shipping lanes. As such, it became the first mark that a vessel sailing from Europe would come upon as it made its passage to New York, some two hundred miles due west. Serving as a landfall for those arriving ships, it was also a point of departure for vessels sailing east.

During the 129 years that lightships served at this station, twelve different vessels had the duty, some more than once. It was probably the most exposed lightship station in the world. Twenty-nine times these ships were forced off their post by severe weather.

In December of 1905, while LV *58* was providing relief on the Nantucket station during a heavy gale, a leak developed in the engine room, causing the ship to transmit the first radio distress call ever sent by an American vessel. The rising water extinguished the boiler furnaces, and the ship was bailed

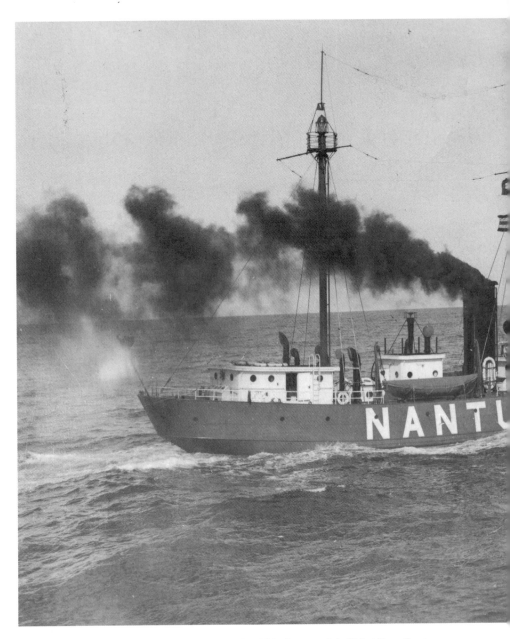

LV *112* steaming toward her Nantucket station in 1936. *Courtesy of the United States Coast Guard.*

by hand for twenty-four hours. The tender *Azalea* arrived the next day and, still in heavy seas, took the lightship under tow. The lightship eventually floundered, but all crewmembers were taken off safely by the tender.

As a neutral country before the United States entered World War I, German submarines called on our ports as goodwill missions. Sometimes, however, their presence was not for purposes of friendship. The Nantucket lightship, marking the principal point of departure from New York to Europe, provided an obvious location for a German U-boat trying to interrupt shipping to their European enemies. On October 8, 1817, *U-53* took up station in the sea lane two miles south of the Nantucket lightship. Here they stopped merchant vessels, and, if any were found to be carrying cargos for Great Britain, the crew was ordered into lifeboats and the merchant ship sunk. Before the day had ended, the lightship had taken aboard 115 sailors from sunken merchant vessels and one fishing boat. Nineteen lifeboats were trailing on a line behind the lightship. Bad weather came soon after and if not for the lightship many of these seamen would not have survived the fifty-mile trip to shore.

In the first eighty years that this station was occupied by lightships, there had been no loss of life. This was about to change, as transoceanic ships would begin to use the radio beacon as a homing device, planning to make a last-minute turn to avoid hitting the lightship.

On January 6, 1934, the 24,500-ton American liner the *Washingon* sideswiped LV *117*, taking away a lifeboat, its davits and some radio gear. On May 14, two other passing ships almost hit the lightship. These occurrences happened so frequently that, during foggy weather, the crew had taken to hanging the lifeboats out for a quick escape.

On the morning of May 15, 1934, in a thick fog, the inevitable happened. About eleven o'clock, having reduced speed several times during the night to about ten knots, the *Olympic*, sister ship of the *Titanic*, approached the lightship. When the lightship was spotted through the fog, there was not sufficient time to avoid a collision. The *Olympic's* rudder was spun hard to port while the port engine was put full astern. Turning slowly and probably doing no more than three knots, she sliced through the lightship, sending the vessel rapidly to the bottom. Captain Binks, of the *Olympic*, immediately had two boats lowered but only managed to rescue four of the eleven-man crew.

In 1936 LV *112* took up this post. At 149 feet and displacing 1,050 tons, this was the largest American lightship built. The British government paid $300,956 to build it as reparation for the sinking of LV *117* by the *Olympic*. This vessel incorporated many new safety features, including much compartmentalization and many exits to the upper deck.

In 1983 a lighted horn buoy replaced the lightship station. Of the nineteen lightships that still existed in 2007, three—LV *112*, WLV *612* and WLV *613*—served on the Nantucket Station.

Wreck of the Oregon, New York

Sailing west from the Nantucket lightship in 1866 there was LV *20* marking the wreck of the steamship *Oregon* about nine miles offshore from Fire Island, New York. This eighty-one-foot sailboat served on the station from April 1866 until November of the same year when the wreck was deemed no longer a danger.

Fire Island, New York

In July 1896 a more permanent station was established about forty miles east of the entrance to New York Harbor. Located just off the Fire Island coast, it was a mark for both transatlantic traffic as well as coastal shipping. Three vessels occupied this post. The first was LV *58*, which was later sunk by bad weather at the Nantucket station.

From 1897 until 1930, LV *68* was the Fire Island lightship. This vessel was 123 feet in length, built with a steel frame and wood bottom. It displaced 590 tons and was powered by steam but was also rigged for sail. A cluster of three 100-candlepower electric lens lanterns at each masthead provided illumination. These were replaced in 1920 by a single acetylene lens lantern at each masthead. The ship's lights were again converted to electricity in 1928 with 375-mm electric lens lanterns. LV *68* was equipped with a radio in 1916 and a radio beacon in 1921.

This vessel was forced off station by the weather several times and was rammed by the SS *Philadelphia* on May 16, 1916. The crew was later commended for the actions they took, such as shifting the coal as well as filling the ship's lifeboats with water and swinging them out to heel the vessel. This action reduced the leakage and kept the ship afloat. The *Philadelphia* towed the damaged vessel part way to port until the tender *Pansy* took her. On March 30, 1924, the LV *68* was again rammed, this time by the SS *Castillian*. The crew again saved the vessel when they patched the resulting large hole.

The last twelve years of operation on this station were provided by LV *114*, which arrived in 1930. This ship was built in Portland, Oregon, and was the first U.S. lightship to make the west-to-east trip passing through the Panama Canal. One of the more modern lightships built, this 133-foot vessel was made of steel, displaced 630 tons and carried a 375-mm electric lens lantern at each masthead. The fog equipment included an air diaphone and a hand-operated bell. The station was discontinued in 1942 and the

New York–Nantucket traffic lane buoyage now marks the area. LV *114* served on several other stations before it was retired on November 5, 1971. Given to the city of New Bedford, Massachusetts, where it never became a museum as planned, it is currently waiting to be sold.

SANDY HOOK/AMBROSE, NEW YORK

The broad entrance to New York Harbor lies between Coney Island, New York, on the north and Sandy Hook, New Jersey, on the south. The opening is an area filled with shoals and sandbars about twelve miles across. In 1823 a lightship was assigned to this Sandy Hook station, located about six miles east of the Sandy Hook lighthouse that had operated since 1764. Built in New York, this ship was a wooden vessel ninety feet long and 154 tons. It served until the station was closed in 1829. It is possible that this was the first lightship to utilize reflector-type lamps.

Those concerned with shipping interests felt it necessary to further mark the area so a lightship station was reestablished about ten years later in 1839, this time by a 230-ton, ninety-nine-foot wooden vessel. It showed two whale-oil lamps that were visible about four miles under good conditions. The weather at this station also proved difficult. In 1850, Henry Hunt, the vessel's master, reported the vessel had gone adrift eighteen times during the prior twelve years, being absent from the station for periods ranging from five weeks to four months.

From October 1854 until 1908, three vessels were assigned to this post. The first of these was LV *16*, a wooden schooner of 250 tons and 126 feet in length. It showed two lanterns, each with eight oil lamps and reflectors. The fog signal was a hand-operated bell. In 1874 the steamer the *Charleston* collided with the lightship, as did the British bark *Star of the East* in 1888. This lightship, which went on to become the last sail-powered vessel of its type when retired in 1935, was replaced on station by LV *48* on August 1, 1891. The 470-ton LV *48* was built in Boston. It was composite, steel-framed, planked with Georgia pine and sheathed with white oak. Two masts carried the lights and there were spencer masts for the schooner-rigged sails to propel the 121-foot vessel. This ship only spent four years at Sandy Hook, but it was notable for several features. It was built with a steam windlass, one of the first three lightships so equipped. The fog signal was a twelve-inch steam bell whistle supplemented by a hand-operated thousand-pound bell. The illuminating fixtures consisted of two oil lanterns. The foremast was fitted with a revolving apparatus consisting of three groups of three oil lamps, each mounted on a chariot inside the lantern housing. This was rotated by weights and made LV *48* the first U.S. lightship with a flashing light.

The new twin lighthouses built in 1883 on the Navesink Highlands became the primary light marking the entrance to New York Harbor, especially after being converted to electricity in 1898.

The 1894 replacement lightship, LV *51*, was the first built with an all-steel hull. Displacing 375 tons, it was 119 feet in length. Propulsion was by a steam screw and the vessel carried 52 tons of coal, but it also had spencer masts for sails. It was one of the first four lightships built having the hawsehole for the anchor chain through the bow on the centerline of the vessel. This vessel was also the first built with an electric illuminating apparatus. This meant that the lanterns did not have to be lowered each day for trimming the wicks, adding fuel and other servicing. A cluster of four gimbaled lens lanterns was fixed at each masthead. Each of these lanterns had a 100-candlepower incandescent lamp that, in conjunction with the lenses, gave an equivalent of 4,000-candlepower. The electricity was provided by two engine-driven generators, one on line and one for backup. Because electricity was still a relatively new technology, backup oil lamps were also installed in each lantern. The more powerful lighting meant that northbound ships could pick up the light five to ten minutes after sighting the Navesink lighthouses. This was a major improvement over the feeble light shown by the previous vessels on the station.

This ship was made a relief vessel in 1908 and on April 24, 1919, while relieving at Cornfield Point, Connecticut, it was rammed by a Standard Oil Company barge that was being towed. The ship sank in eight minutes but there was no loss of life. Compensation from the oil company paid the $219,883 necessary for the construction of LV *111* in 1926.

In 1899 the U.S. Congress approved a $4 million improvement to the New York harbor entrance. The improvement meant dredging a channel forty-five feet deep and two thousand feet wide. This is known as the Ambrose Channel, and, as it was developed, a number of navigational aids were incorporated. This included the Sandy Hook lightship station being moved to a new site eight miles east of Rockaway Point on Long Island and renamed Ambrose.

The first ship on this new location, about twenty miles from the tip of Manhattan, was the LV *87*, displacing 683 tons. Built by the New York Shipbuilding Company in Camden, New Jersey, its 135-foot steel hull was powered by steam. It carried two steel masts for the lights and daymarks but still had a spencer for sail. The ship was originally equipped with oil lanterns, which were soon replaced with electric incandescent lights and then converted to an arc light. The lighting switched back and forth several times until, in 1922, the vessel was equipped with two 375-mm electric lens lanterns of 15,000-candlepower. The fog signal was a twelve-inch steam

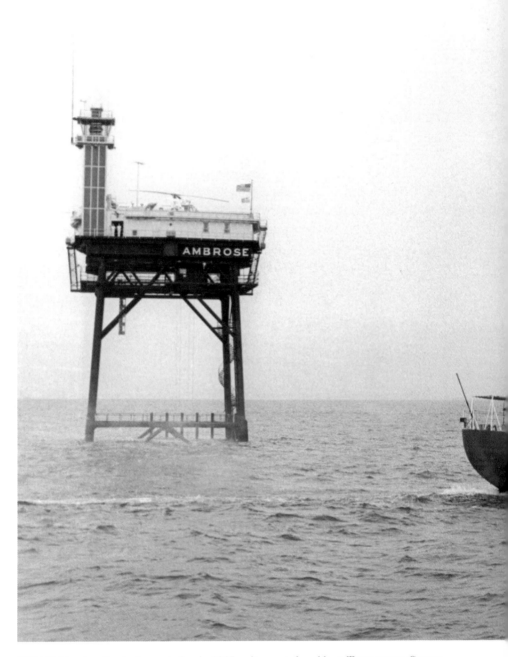

WLV 613 leaving the Ambrose station in 1967 as it was replaced by a Texas tower. *Courtesy of the United States Coast Guard.*

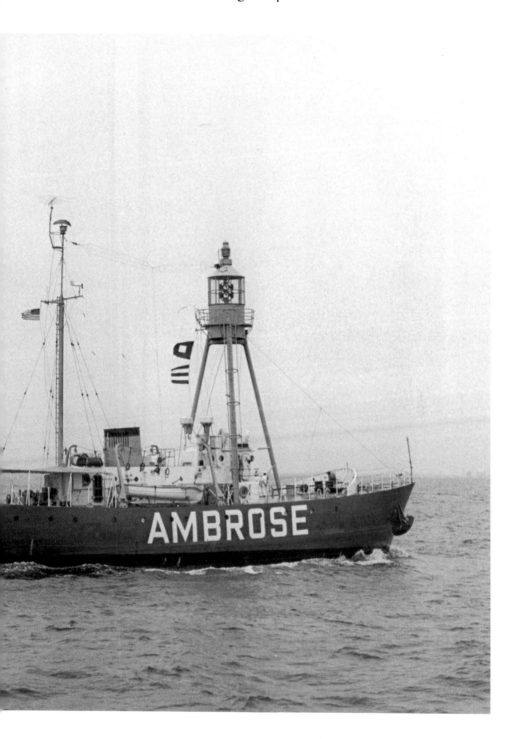

chime whistle and a hand-operated bell. This lightship was equipped with a radio in 1918 and was among the first three U.S. lightships to receive radio-beacon equipment in May 1921. This vessel was withdrawn from service in 1932 for overhaul and refitting. A 300-horsepower Winston Diesel engine was installed at this time, as well as diesel equipment to generate electricity. The fog signal was changed to an air diaphone in 1934. LV *87* went on to serve at various stations, including the Scotland, New Jersey station, for another thirty years. The ship was retired in 1962 and donated to the South Street Seaport in New York City, where today it floats as an exhibit.

The 1932 replacement was LV *111*, one of five sister ships built by Bath Iron Works in Maine. Before coming to the Ambrose station, this vessel covered the Northeast station until it was closed in 1932. The twenty years served at Ambrose included World War II, when it remained at its post without any armament. The German U-boats probably used the lightship to help them navigate, so it was to their advantage to leave it unharmed. However, the Germans did, in view of the lightship, torpedo and sink the destroyer USS *Turner* on January 3, 1944.

The liner SS *Santa Barbara* collided with LV *111* on September 17, 1935, causing some damage above the water line. After being relieved in 1952, LV *111* served at Portland, Maine, and after decommissioning went either to a ship-breaking yard in Bordentown, New Jersey, or was donated to the government of Uruguay. The records are not clear about its final disposition.

It is fitting that the last lightship built, and one of the six built by the U.S. Coast Guard, was the final vessel serving the Ambrose station. The 144 years lightships were positioned at Sandy Hook/Ambrose was the longest any station operated during the 165 years of the lightship era. The 128-foot WLV *613*, displacing 617 tons, was built in 1952 for the Ambrose station. The vessel served here until the station was discontinued in 1967 and was replaced by a Texas tower, so named because of the resemblance to the oil rigs in the Gulf of Mexico.

Originally the ship was equipped with a 375-mm duplex electric lens lantern. This was later replaced by two sets of four eighteen-inch parabolic mirrors revolving around two 1,000-watt lamps, located in a large tripod housing placed on the foredeck. It was of British design and is rated with a variable light intensity of between .25 million and 5-million candlepower. This vessel went on to be the final ship at the Nantucket station when it was closed in 1983. It is now in private hands, berthed in Wareham, Massachusetts.

On a foggy morning June 24, 1960, the cargo vessel *Green Bay* left New York Harbor for Bombay, India. At 4:03 a.m., as the pilot departed the ship, a radio bearing was taken on LV *78*, the vessel that was relieving WLV *613* on the Ambrose station. The *Green Bay* set her speed at half full, or 7.5

knots. At this time visibility was zero. Five minutes later, at 4:08 a.m., the lightship watch spotted the *Green Bay* heading toward them, and, about the same time, the watch on the *Green Bay* spotted the lightship. But it was too late and the vessels collided at 4:11 a.m., sinking the lightship. The crew took to a life raft, and this raft was almost rammed by the *Queen Elizabeth*, who didn't spot them. Eventually they were rescued by a launch from the *Green Bay* and transferred to a coast guard vessel. The Joint Marine Board of Investigation found that the *Green Bay* was negligent because of immoderate speed and failure to fix its position by either radar or the radio direction finding equipment.

SCOTLAND, NEW JERSEY

Another misfortune created the Scotland station located a little over 3 miles from Sandy Hook and about 4.5 miles west of the Ambrose station. In 1866 the steamer *Scotland* collided with the schooner *Kate Dyer* near Fire Island. The schooner sank and, taking on water, the *Scotland* was run aground where it sank. In 1868 the 165-ton LV *20* was assigned to alert passing ships of the situation and the station was named "Wreck of Scotland." This lightship was an eighty-two-foot wooden schooner.

Two years after the collision, the sunken steamer was moved to deeper water and the station was discontinued. In 1874, it was reinstated as the Scotland station, because of the demands of shipping interests. LV *23* was positioned there. This was the fourth post for the ninety-five-foot, 186-ton wooden schooner built in 1857 and converted to a lightship in 1862. This craft carried two lanterns with eight oil lamps and a 667-pound hand-operated bell. After two years on this station the vessel served at four other stations before being sold in 1925.

LV *20* then spent four years at the Scotland station. In 1880, the station was taken over by another schooner, the small, 142-ton, ninety-eight-foot LV *7*, on her fifth post. This ship carried two lanterns with eight oil lamps each, and a five-hundred-pound, hand-operated bell. Serving ten years at Scotland, and then two other assignments, this vessel was sold for $155 on May 29, 1909.

Twenty-three years, from 1902 until 1925, was the longest service for any ship at this station. That honor belonged to the 320-ton LV *11*. This 104-foot schooner was built of white oak at Baltimore in 1853. The equipment included two lanterns with eight oil lamps each, and a thousand-pound hand-operated bell. The illumination was changed to gas in 1912. After surviving at least three collisions while on station, this ship was retired in 1925 at seventy-two years old. It had the distinction of being the oldest vessel in lightship service at the time.

The next eleven years, until 1936, were covered by LV *69*, stationed here after twenty-five years at the Overfalls Shoal at the entrance to the Delaware Bay. LV *87* then covered this post until 1942.

During World War II a buoy marked this location. In the two years following the war, LV *78* occupied the position. This vessel was an 129-foot steel-hulled boat displacing 668 tons. The original steam propulsion was replaced by a 600-horsepower General Motors diesel engine in 1934. A 375-mm acetylene lens lantern was carried and the ship was equipped with radio and a radio beacon. It was later sunk by a collision while on relief duty at the Ambrose station.

The last fifteen years this station operated, it was covered by LV *87*. After serving at the Ambrose station and four years as a relief ship, this vessel spent four years at the Scotland. Starting in 1942, it became an armed examination vessel for the duration of World War II. When the war ended it spent three years at Vineyard Sound before returning to Scotland from 1947 to 1962 when the station was closed and LV *87* was donated to the South Street Seaport in New York City.

BARNEGAT, NEW JERSEY

Along the coast of New Jersey, there is an obvious westward bend in the coastline at the Barnegat Inlet, about forty-one miles south of Sandy Hook. This is where the coastal traffic, traveling north or south, to and from New York, needs to make a course change. A small and inadequate lighthouse was established on the shore in 1834. After erosion caused this structure to fall, a new lighthouse was built in 1858. It had a first-order Fresnel lens 165 feet above sea level, but evidently this was not sufficient for the passing mariners. There were proposals for a lightship here, supported by a report listing fifty or more vessels stranded on the New Jersey coast between 1904 and 1923. Approval was given in 1927 to establish a lightship station.

LV *79* covered the post from 1927 until 1967, with three years out for duty as an examination vessel during World War II. During the war a buoy marked the position. LV *79* was a 129-foot, steel, steam-powered vessel that displaced 668 tons. It had two steel masts but also spencers, as it was initially rigged for sail. By the time it arrived at Barnegat, it had a 375-mm acetylene lens lantern on each masthead, a radio, a submarine bell, a twelve-inch steam chime whistle and a hand-operated thousand-pound bell. In 1931 it was repowered with a 310-horsepower Cooper-Bessemer diesel engine, and the fog signal was changed to an air diaphragm two years later. Upon retirement this vessel was donated to the Chesapeake Maritime Museum and was later sold to a group at Penns Landing in Philadelphia. Subsequently it has been placed at a ship junkyard in Camden, New Jersey.

The final two years, before this station was replaced by a buoy, it was served by LV *110*. One of five sister ships built in Maine by the Bath Iron Works in the 1920s, it is 132 feet in length with a steel hull, displacing 775 tons. Repowered with a 500-horsepower General Motors diesel engine and carrying a duplex 375-mm lens lantern on the foremast, this vessel arrived at Barnegat after seven previous assignments. When this station was closed in 1969, the ship went on to serve the final year of its career at the Five Fathom Bank station near the Delaware Bay. Decommissioned November 3, 1975, it is reported to have been scrapped at Dorchester, Massachusetts, that same year.

Chapter 6

Outside Lightships—Mid-Atlantic

NORTHEAST END, NEW JERSEY

From the Barnegat lightship, sailing southwest another fifty-four miles with a course set at about two hundred degrees and staying just outside the thirty-foot fathom contour (where the white on the chart turns to blue) we find the Northeast End lightship station. This was the northernmost lightship of the group marking the entrance to the Delaware Bay. The station served as a reference mark for coastal traffic. It was maintained for fifty years, from 1882 until 1932, and is now marked by lighted buoy "2FB."

The ship was located about twelve miles offshore from Hereford Inlet, New Jersey, where a lighthouse was activated in April 1874. Historically, the light had a visible range of thirteen miles, although a current light list gives this range as twenty-four miles. Nine miles southwest was the Five Fathom Bank lightship, carrying a light with a visible range of thirteen to fourteen miles.

The first lightship built with an unsheathed metal hull, LV *44* served forty-five years on the Northeast End station from 1882 until 1926. This 116-foot, 197-ton ship was schooner-rigged and, when retired in 1938, it was the last lightship in service not propelled by any type of machinery. The original illuminating apparatus consisted of two oil lamps with reflectors, which were converted to acetylene lens lanterns in 1912. A submarine bell signal was installed in 1910 and a radio in 1919. This vessel did have some steam equipment to operate its twelve-inch whistle so the crew didn't need to hand operate the thousand-pound bell every time the fog arrived. The ship seemed to have many maintenance problems, and the record suggests the wisdom of building iron lightships without wood sheathing was questioned. This vessel was reassigned to Cornfield Point in Connecticut, where it was severely damaged in the 1938 hurricane and subsequently retired.

LV *111*, with its 375-mm electric lens lantern at each masthead radiating 15,000-candlepower, covered the station for the final six years of its

operation. Paid for by The Standard Oil Company in reparation for the sinking of LV *51* in 1919, this 132-foot vessel was one of six sister ships built in 1923 by Bath Iron Works in Maine. It was the first lightship built with full diesel propulsion and displaced 775 tons. In 1932 it was relocated to the Ambrose station.

FIVE FATHOM BANK, NEW JERSEY

Approximately ten miles southwest is the Five Fathom Bank station. While this location was recommended in 1826, the official record shows that this station was initiated in 1837. There is evidence, however, that lightships, either government or private, operated here as early as 1835.

Reflecting perhaps the importance of the Delaware River ports, this station lasted 135 years, which tied the years of the Cross Rip station in Massachusetts, and was second in longevity to the 144 years that the Sandy Hook/Ambrose station was operated. During these years, the covering lightships were blown or dragged off station a total of eleven times.

For the first thirty years, this post was occupied by LV *18*, which was built for this location by Benjamin Pomeroy at Stonington, Connecticut. This schooner-rigged wooden sailing vessel was a ninety-foot craft as measured between the perpendiculars. The sails were carried on spencer masts. At 195 tons, it had two masts for the lanterns each of which had eight lard-oil lamps with twelve cylindrical wicks. These lamps were replaced in 1855 by the Argand-type with twelve-inch reflectors. There was a hand-operated bell that was rung when visibility was poor.

After being driven off station a number of times by the weather, the ship was replaced in 1869. It then served six years as a relief vessel before it was declared unseaworthy and sold to the navy for use as a target in torpedo practice.

LV *37* occupied this post for the next seventeen eventful years until it was relieved in 1876. Built at Philadelphia this was a ninety-eight-foot, 242-ton wooden schooner. It had its sails carried on spencer masts while the two main masts each carried a lantern with eight oil lamps. The fog signal was a thousand-pound hand-operated bell. The vessel was in for repairs a number of times during her stay at Five Fathom Bank. Three times during the period, storms caused the chains to part and the boat was blown off station. On April 22, 1874, while returning to the lightship from a shore trip, the liberty boat capsized in heavy weather. Only one of the five crewmembers aboard was rescued by a pilot boat that happened to be nearby. In 1881 the station was moved southeast about six miles because of shoaling.

The next twenty-seven years, between 1877 and 1904, found LV *40* on this station, which had again been moved somewhat more than a mile to

the southeast. This placed the station about seven miles southeast of the original spot.

After two years at Pollock Rip in Massachusetts, LV *40* was assigned to the Five Fathom Bank station. It was a larger ship at 114 feet and listed at 349 tons. The craft was outfitted with a steam pump to operate the twelve-inch steam whistle, carried in addition to a thousand-pound bell. This vessel also suffered from the weather, and in one case, the forecastle and cabin were partially flooded by boarding seas, the ship's boats were smashed and the anchor chain parted.

In 1893, while LV *40* was undergoing an extensive refitting, LV *37* served as the relief vessel. A hurricane hit the area on August 23 and 24, and LV *37* became the first U.S. lightship to sink while on station. This happened because of some judgment errors and poor seamanship. Four members of the six-man crew were lost. The following investigation found that the spare chain had not been properly secured, and it slid into the lee scuppers, causing the vessel to list. Hatch covers, companionways and other openings were not adequately closed and the anchor chain had not been let out to the full scope as required. The USS *Vesuvius*, a U.S. Navy gun cruiser, later blew up the wreck on October 16, 1893. LV *40* returned to the station and continued her service until funds were appropriated for a steam-propelled vessel to take her place in 1904.

The Lightship Service was busy in 1904, building six new ships. One of these was built on the Great Lakes and the other five were sister ships built by New York Shipbuilding in Camden, New Jersey. The second of these was LV *79*, 129 feet in length, with a steam screw and a steel hull. It had two steel masts and spencers so it could also be operated by sail. It displaced 668 tons. The ship carried a cluster of three oil lens lanterns for each mast, a twelve-inch steam chime whistle and a thousand-pound hand-operated bell. Later, in 1910, it was equipped with a submarine bell signal, and a radio was added in 1918. The lighting apparatus was changed to 375-mm acetylene lens lanterns, replacing the two original oil lamps in 1921. After a rather uneventful twenty-year stay at the Five Fathom Bank station and two years as a relief vessel, this lightship was repositioned at the Barnegat station. This is where it served the rest of its career with time out during World War II when based at Edgemore, Delaware, and used as an examination vessel.

LV *108* undertook the Five Fathom Bank duty in 1924. This 132-foot vessel, displacing 775 tons, was one of the six 1923 sister ships built by Bath Iron Works. The Maine-built ships were steam screw propelled with a steel hull and deckhouses and were equipped with 375-mm electric lens lanterns at each of the two mastheads. Also carried were a twelve-inch steam chime whistle, a submarine bell and a hand-operated bell. The fog signal was

changed to a steam diaphragm horn in 1935. While on station June 8, 1929, a coast guard amphibian airplane made a forced landing nearby and the lightship crew was able to save both the pilot and the aircraft. Both were later taken ashore by the tender. After a brief stint as a relief vessel, LV *108* served at this station almost her whole life of forty-seven years. For three years during World War II, the lightship was another of the Edgemore, Delaware, examination vessels, in this case armed with a 6-pounder. In LV *108*'s absence, a buoy marked the station. The vessel is reported to have been scrapped in 1975.

Sister ship LV *110* took the station during the 1970–1971 period. On this vessel, the steam propulsion had been replaced by a 500-horsepower General Motors diesel engine in 1958, and a duplex 375-mm lens lantern, each with 15,000-candlepower, installed on the foremast. This vessel was decommissioned November 3, 1971, and scrapped several years later.

During its last year as a lightship station, WLV *189* covered the post. This vessel was the first U.S. Coast Guard–built vessel. It was 128 feet in length and displaced 630 tons. It was also the first welded lightship built, and the first designed and built with alternating electrical current throughout. Additionally, the hawsepipes carried to the weather deck, thereby keeping the forward below-deck area dry. The unique light arrangement consisted of twenty-four locomotive headlights, mounted in groups of six on each of the four sides of a revolving lamp housing. This was on the main mast while the foremast carried the standard 375-mm duplex lens lantern. This vessel then went on to serve the Boston station until 1975 followed by a few years as a museum in Atlantic City, New Jersey, before it was scuttled to make an artificial reef off that city's coast.

The Five Fathom Bank station was marked by a lighted horn buoy in 1972. The buoy also marks the eastern entrance of the Five Fathom Bank–Cape Henlopen Traffic Separation Zone.

OVERFALLS, DELAWARE

About halfway between the entrances to New York Harbor and the Chesapeake Bay is the entrance to the Delaware Bay and Delaware River. One hundred miles up the river is the major port city of Philadelphia, and ports in Camden, Wilmington and many other cities supplement it. Philadelphia's hinterland was expanded when the Chesapeake and Delaware Canal opened in 1829. Financed by Philadelphia's business community this canal tied the northern Chesapeake Bay and Susquehanna River areas to the north and the Philadelphia region. It also provided a shorter route for shipping from Europe to reach Baltimore, up the bay and through the canal, rather than going farther south to the entrance of the Chesapeake Bay.

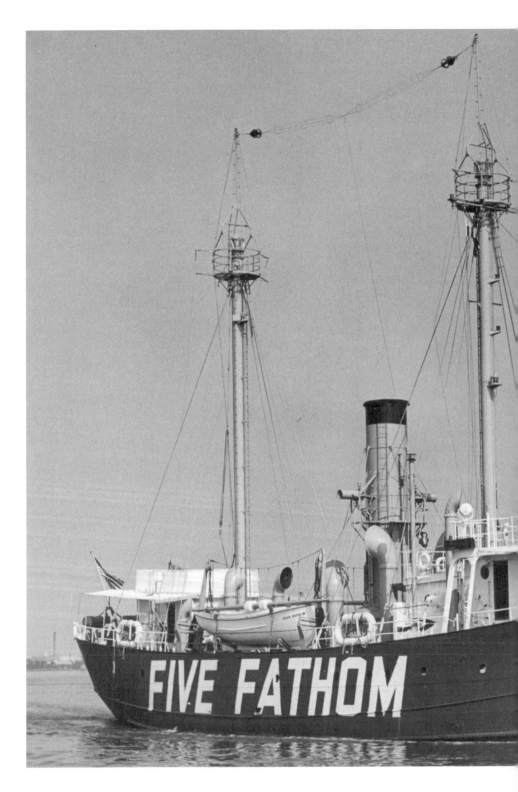

LV *108* moving to Five Fathom
Bank after World War II. *Courtesy
of the United States Coast Guard.*

With these location factors, the area became quite important to shipping and saw a lot of traffic. The Philadelphia Maritime Exchange set up an office in Lewes, Delaware, to give and receive messages from vessels and to provide the assistance of pilots for going up the river. A breakwater was built during the forty years between 1829 and 1869, forming a wall to protect ships from northeastern storms. At the turn of the next century, between 1897 and 1901, another breakwater, the Harbor of Refuge, was built in the same general area. This 1.5-mile rock wall produced a refuge of approximately 550 acres and served to protect vessels from the severe storms that often ravage this part of the world. Both of these breakwaters ultimately had a lighthouse on their eastern ends.

Marking the ocean-side entrance to the bay, at the intersection of the east-west and north-south shipping channels, was the Overfalls lightship station. It was named for the Overfalls Shoal, which is located just north of the lightship position. The vessel sat about 8.5 miles south of the Cape May lighthouse and about 3.5 miles east of the Cape Henlopen lighthouse. The station was established December 2, 1898, and was moved about a mile southeast of its first location in 1944. Four different ships served on the station. The first of these vessels was LV *46*, serving from 1898 until 1901. This vessel, a schooner-rigged sailboat, was built in 1887 at Linwood, Pennsylvania. It had a steel-framed, iron hull sheathed with yellow pine and was 124 feet long and displaced just over 400 tons. Two lanterns comprised the illuminating apparatus, each lantern having eight oil lamps with reflectors. The fog equipment consisted of a twelve-inch steam whistle and a hand-operated thousand-pound bell. This vessel had previously served several posts along the Virginia coast and, after three years at Overfalls, was again moved south where it was retired in 1923 and probably sold. No records seem to exist concerning its final disposition.

Starting in 1901, the next twenty-four years saw this post covered by LV *69*, which had been recovered after being driven ashore near Cape Hatteras by a hurricane two years earlier. This ship carried a coal-fired steam engine but was also rigged for sail. The equipment included a twelve-inch steam chime whistle and a hand-operated thousand-pound bell. A submarine bell signal was added in 1907 and the ship was equipped with a radio in 1919. The original lighting was a cluster of three 100-candlepower, electric lens lanterns that were permanently mounted in a gallery at each masthead. In 1920 the lighting system was replaced with a single acetylene lens lantern at each masthead. During its stay at the Overfalls station, this ship was dragged off its location several times by ice. When it left the Delaware waters, it was assigned to the Scotland station in New Jersey where it remained until retired in 1937. No records exist concerning its final disposition.

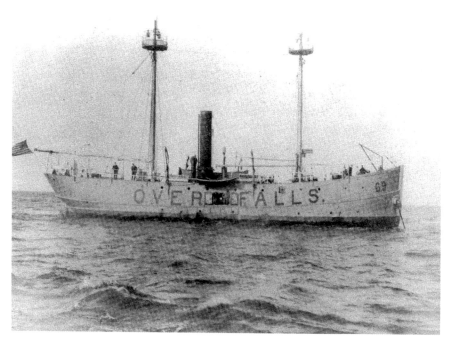

LV *69* on station at the Overfalls Shoal. *Courtesy of the United States Coast Guard.*

A self-propelled steel whaleback vessel was the next assigned. LV *101* was built in Wilmington, Delaware, in 1916. This ship was 102 feet long with a kerosene engine. It displaced 360 tons. By the time it was assigned to the Overfalls station, the original kerosene lamp had been replaced with acetylene. Two 40-horsepower kerosene engines drove compressors to operate an air siren, which along with a submarine bell and a thousand-pound hand-operated bell, constituted the sound equipment. By the end of this ship's stay, the lights were duplex 375-mm lens lanterns installed in 1931. These were 13,000-candlepower and the original lantern housing had been removed. In 1944 a 315-horsepower Cooper-Bessemer diesel engine repowered the vessel. It was equipped with a radio in 1919. During World War II, this vessel stayed on station with no armament. There was a major coast artillery installation at Fort Miles on Cape Henlopen and the mouth of the Delaware Bay was mined during this period.

After leaving the Overfalls, LV *101* was assigned to Stonehorse Shoal in Massachusetts until it was retired in 1964. The vessel is now at the Portsmouth Lightship Museum in Virginia.

The final occupant of the Overfalls station, WLV *605*, was one of the six lightships built by the U.S. Coast Guard. This 128-foot diesel-powered vessel, displacing 617 tons, was built in 1950 for the Delaware location and

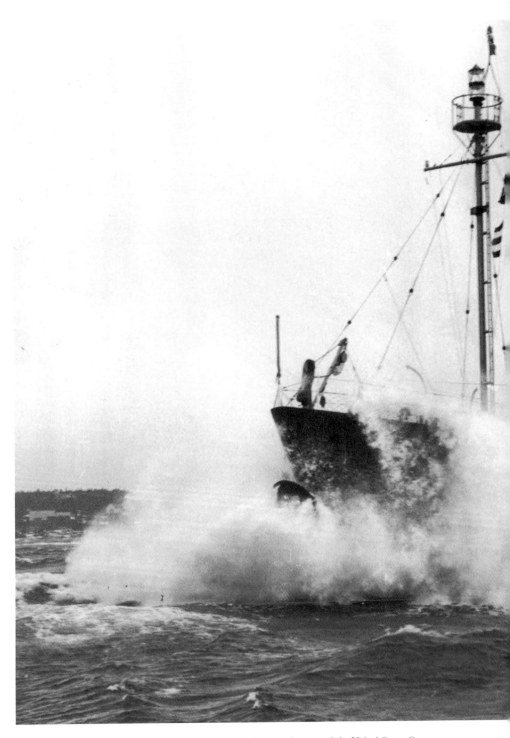

WLV *605*, the last vessel stationed at the Overfalls Shoal. *Courtesy of the United States Coast Guard.*

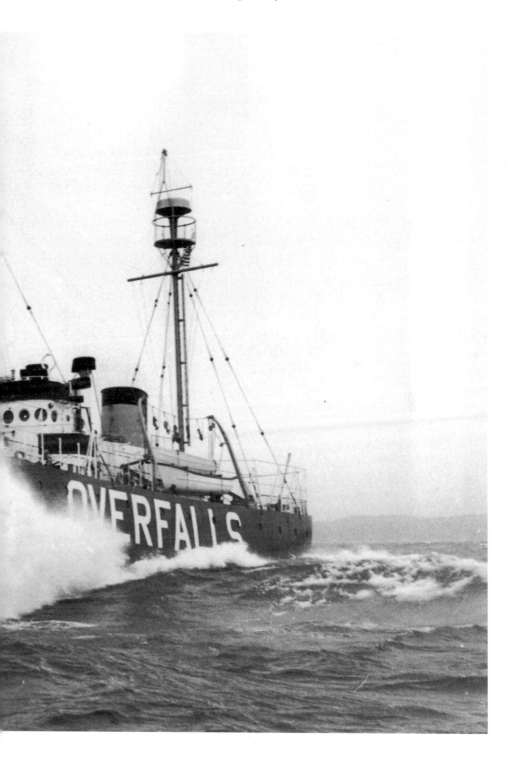

served there for nine years. Originally carrying duplex 500-mm, 15,000-candlepower electric lens lanterns on each mast, a 1965 light list shows that the mainmast light had been changed to a high intensity 500,000-candlepower lamp, and that the ship carried a 375-mm duplex lens lantern on the foremast.

The Overfalls lightship station was discontinued November 15, 1960, at the same time the Delaware station was activated. Buoyage now marks the location. WLV *605* was then sent to the West Coast where she spent nine years at Blunts Reef, California, before becoming a relief vessel until retired in 1975.

FENWICK ISLAND SHOAL, DELAWARE

A little over five miles east of where the Maryland and Delaware state boundaries meet at Fenwick Island there is a two-mile shoal with good water on both sides. Its location caused many casualties and a lightship was stationed here on October 29, 1888. LV *37* was built in 1869 and, after serving at Five Fathom Bank (1869–1876) and Winter Quarter Shoal (1876–1888), it became, in 1888, the first vessel placed on this shoal.

The Lightship Board, in a report to Congress in 1889, felt this vessel lacked what was needed, such as a steam fog signal, and should be replaced by a more modern vessel. LV *37* could then be used as a needed relief ship. To justify their request, they listed a number of merchant ships that had wrecked on these shoals over the years. The schooner-rigged sailboat served the post for four years before a steam-powered lightship replaced her in 1892. The sailing ship became a relief vessel and sank during a hurricane while relieving at Five Fathom Bank the next year.

The new 310-ton lightship at Fenwick Island, LV *52*, was 119 feet long, powered by steam but also rigged for sail with spencer masts. It was one of the first four lightships to have the hawsepipe located in the center of the bow, which improved both its anchor-holding capacity and the stability of the vessel during a storm. The lighting apparatus consisted of two lanterns, each with eight oil lamps and reflectors. A twelve-inch steam chime whistle was carried as well as a hand-operated thousand-pound bell. During the thirty-eight years LV *52* served the station, the vessel faced one major hurricane in September 1928. The ship remained on station receiving no serious damage. Throughout this period, the station was moved two times to a location between five to six miles farther east.

Many equipment changes took place through the years, mirroring the improvements in technology. Wood stoves, replacing coal, were installed to heat the crew quarters in 1893. In 1906 a submarine bell was installed, and the fog signal was converted to an air siren in 1912.

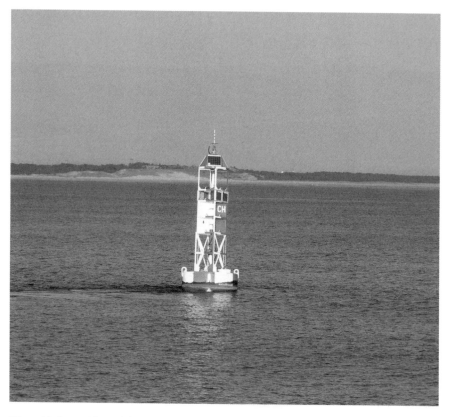

The mid-channel buoy where the Overfalls lightship once sat. *Photograph by Captain Rick Yakimowicz.*

In 1915 the Fenwick lightship took on board thirty-nine shipwrecked men from the steamship SS *Washington*, which had sunk nearby.

The lighting illuminant was changed from oil to oil-gas in 1916 and then to acetylene in 1917. A radio came in 1919 and the original lanterns and lantern houses were removed in 1923. These were replaced with galleries and 500-mm electric lens lanterns using special 150-watt bulbs, rated at 5,500-candlepower. In 1930 LV *52* was relegated to relief duty where it served for two years before it was retired and sold in 1932.

The final vessel on this station was LV *116*, a 133-foot-long diesel-electric-powered ship, displacing 630 tons. It had a 350-horsepower electric motor driven by one or all of the ship's four diesel generators. The equipment carried included 375-mm electric lens lanterns at each masthead, an electric diaphragm four-way multiple horn and a hand-operated bell. This lightship served at Fenwick for about three years, until the station was discontinued June 30, 1933. It was replaced with a lighted whistle buoy another 2.5 miles

south of its last position. A buoy still marks the southern approach to the Delaware Bay. LV *116* then spent about thirty-two years at the Chesapeake station with time out to serve as an examination vessel during World War II. Her final five years of service were at the Delaware.

DELAWARE, DELAWARE

Delaware, the next-to-last lightship station established by the U.S. Coast Guard (the last was off New Orleans, Louisiana) was about nine miles west of the former Fenwick Island station. It opened November 15, 1960. The first assigned vessel was LV *107*, which spent most of its life at the Winter Quarter and will be described in the next section. In 1965 it was replaced by LV *116*, which after many years at Fenwick Island and Chesapeake stations, ended its career with the closing of the Delaware station five years later. A lighted horn buoy has marked this area since 1970. Located about five miles west of the old lightship position, this buoy now marks the southern entrance to the Delaware–Cape Henlopen Traffic Separation Zone.

WINTER QUARTER SHOAL, VIRGINIA

The last station before the entrance to the Chesapeake Bay occurs at a slight bend in the shoreline along Assateague Island. The lightship station here served as a point of reference for coastal traffic as well as marking the approach to the Chesapeake Bay. The position also marks shoaling water between twelve and twenty-five feet deep (according to modern charts), extending in a southwest-northeast direction. This Winter Quarter Shoal is about six miles offshore, and the lightship was placed another two miles east of the shoal.

In 1833 a lighthouse was established at Assateague, but reports indicate the light was not strong enough to reach the shoal areas off the shore. The present light was completed October 31, 1867, and light lists today indicate the visible range of this 154-foot structure as being twenty-two miles.

LV *24*, a ten-year-old wooden sailboat seventy-seven feet in length and 115 tons, was assigned to the Winter Quarter station November 15, 1874. It was equipped with two lanterns, each holding eight oil lamps and it had a hand-operated bell. After a year, an even older vessel, LV *2*, replaced it. A little larger, this was another wooden sailboat ninety-eight feet in length and 210 tons. This craft carried a single lantern, with eight oil lamps with reflectors on its main mast. While LV *24* was sold for $200 in 1890, LV *2* continued to serve at other stations and was seventy-three years old when retired and sold for $76 in 1922.

After seven years stationed on Five Fathom Bank, the schooner LV *37* was overhauled and repaired, at a cost of just over two thousand dollars,

and reassigned to Winter Quarter Shoal in 1876. It needed more repairs in 1880 and, two years later, was fitted with a new mainmast, new rigging, tiller chains and lantern houses lined with tin and floored with copper. It was relieved in 1888 and, in 1893, went on to sink during a storm while on the Five Fathom Bank station.

In 1887 LV *45* was built at Linwood, Pennsylvania. Displacing four hundred tons, this 124-foot vessel had a steel frame with an iron hull sheathed with yellow pine. It had a hand-operated bell and, while its main propulsion was by sail, it carried two auxiliary boilers and a steam pump to operate the twelve-inch steam whistle. During the twenty years the ship was stationed at Winter Quarter, it was blown off station several times. On April 7, 1889, the British steamer the *Viola* took LV *45* in tow about thirty-eight miles off Cape Hatteras, delivering it to Portsmouth, Virginia. Again on December 15, 1896, the British steamer *Birdoswald* towed it to Hampton Roads, Virginia. Finally, damaged by a gale in 1908, it was considered unfit for use on exposed stations and reassigned to the Thirty Five Foot Channel station in Virginia, where the ship remained until retired and sold in 1918.

The location of the station was changed two times, the first a small southeasterly change and the last, in 1909, when it was moved about eight miles further east. LV *91* was the vessel on station when the post was relocated.

Built in 1908 this was the ship's first permanent assignment, one it held until 1934. The vessel was steam-propelled, 135 feet long, displacing 685 tons. Its illumination consisted of a cluster of three oil lens lanterns at each of the two mastheads. The fog signals included a twelve-inch chime steam whistle and a hand-operated bell. A submarine bell was installed in 1908. In 1915 the illuminating apparatus was converted to acetylene and a radio was installed in 1919.

Severe weather caused the anchor chain to part on June 12, 1915, and February 5, 1920. It happened again January 8, 1922, when a heavy gale parted the chain. This time the ship could not maintain its position and was carried 135 miles to the south. It was unable to return to its post, where a tender was waiting with a new anchor and chain. Another storm broke the chain again in 1927. Before LV *91* was reassigned in 1934, the lights had been changed in 1924 to 375-mm electric lens lanterns for each masthead and a radio beacon was added in 1927. The fog signal went through several progressions, first to a steam diaphragm horn in 1932 and then eventually to an air diaphone in 1934. This vessel served in a relief capacity until it was retired in 1961 at the age of fifty-three.

The last lightship on the Winter Quarter station was another of the six sister ships built by Bath Iron Works in 1923. The LV *107* spent the first ten years of its service at Cape Lookout Shoals off the North Carolina coast.

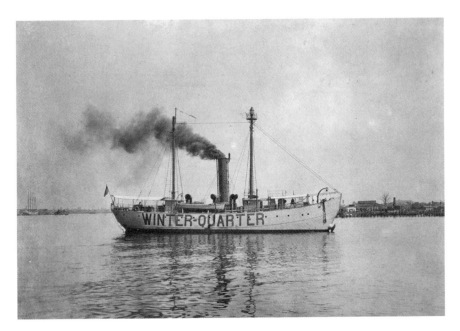

LV *91* ready for the Winter Quarter Shoal. *Courtesy of the United States Coast Guard.*

Assigned in 1934, the ship served at Winter Quarter until the station was closed in 1960. One of the more modern ships, it was 132 feet long and displaced 775 tons. A 375-mm electric lens lantern at each masthead provided the lights, and it was equipped with a radio and a radio beacon when built. The original steam propulsion was converted to a 400-horsepower General Motors diesel engine in the 1940s. The fog apparatus included a submarine bell, and the foghorn progressed from a twelve-inch steam chime whistle to a steam diaphragm and finally to an air diaphone by 1959. This vessel was forced off station four times because of hurricanes and several times received significant damage. The lightship was decommissioned in 1968 and was intended to become a museum in Hampton, Virginia. However, it ended up at a ship-breaking yard at Bordentown, New Jersey, where it was eventually rescued to become an office at Liberty State Park in New Jersey.

After eighty-six years of coverage by a lightship the Winter Quarter Shoal was marked by a lighted bell buoy near the original station position in 1960.

Chapter 7

Crew Life

When a sailor gets to thinking
He is one of the best
Let him ship out on a lightship
And take the acid test.
If he still feels like bragging
I don't think that all his tales
Will be of deep sea sailing,
But of the ship that never sails.
C. Tucker

Anchored where the threat of danger is greatest and the shipping traffic is heaviest, rolls the ship that never sails. The lightship must remain on station in all weather conditions, which leaves it subject to the worst the sea can provide.

Early lightships were poorly designed for their duties. The shape of the hull resulted in an unstable vessel when at anchor. The ground tackle, anchors and the lines securing them were not very strong, and the vessels often broke away from their position. Powered by sail, it was a difficult chore to return to their station, especially in the bad weather that caused them to stray. The lamps were primitive, requiring constant trimming of the wicks and cleaning of the glass, and to top it off, the lantern housings that were manually hauled up the masts often weighed several tons. After the summer heat, the cold winters often required ice to be chipped from the lanterns and rigging of the ship. Meal preparation is best left to the reader's imagination. Fortunately, life aboard these ships that went nowhere changed as the years went by. Alternately hazardous and tedious, boring yet dangerous, uncomfortable, cruelly hard and pleasantly enjoyable, the demands of the sailor's life were always exacting and of utmost importance.

The operation of the early lightships was not dependable or efficient. The ships were operated on a contract basis with their crews drawn from the local community. Farmers and other landlubbers were frequently hired as officers and crew. Their lightship duties were often neglected, as they had many other interests. Willard Flint stated that such personnel could not be classified as seamen in terms of either inclination or competence.

Those lightships most exposed to the elements, the "outside" ones, usually had a crew of fifteen officers and men. The size of the crew tended to get smaller, sometimes down to three men, on some of the smallest inside ships. An old story about the years when the Lighthouse Service ran the ships, often repeated and as quoted by Gustav Kobbe, tells of one crewman who when asked to return to lightship duty declined, saying, "If it weren't for the disgrace it would bring on my family I'd rather go to state prison."

In 1891 Kobbe wrote about his adventures on the Nantucket lightship, then called the "South Shoal Lightship." The crew of this lightship spent four months at sea, then a month ashore. For five months during the winter the tender, *Verbena*, did not even attempt to reach the ship. The lack of refrigeration made for dietary monotony. The most frequent offering was "scouse," a commingling of salt beef, potatoes and onions. Dumplings were served with a sauce of melted brown sugar; occasionally raisins or dried apples were added. All this was prepared and eaten while the vessel was pitching and rolling. The work routine dictated that the lanterns be lowered each morning, the lamps removed from them and taken below to be cleaned and filled with oil. This was a two-hour job in calm weather but might take considerably longer when the weather was in a different state. During the remainder of the day, the crew perhaps cleaned the vessel, caught some fish or just killed some time. At dusk the lamps were lit and the lanterns hoisted. This life as described was before the advent of radio, so the only communication with the outside world, aside from the lightship tender, came from passing vessels that sometimes left fruit or newspapers with the lightship.

Duties aboard the vessel were prescribed in very detailed operating manuals as seen in selected excerpts from the *Instructions to Masters of Light-Vessels, 1902.*

> *77. All absences from light-vessels (including time of leaving and returning and commencement, end and duration of fogs, with the names of the men in charge of fog signal shall be entered in the log...*
> *79. The master of a light-vessel is responsible for the safety and good order of the vessel as well as for the care of all stores, utensils and apparatus of every description on board the vessel. In case of any embezzlement,*

waste, or failure to account satisfactorily for any article of public property, he will be required to pay the full value thereof, and be liable to dismissal from the service...

81. The master must keep a daily account of all stores expended. At the end of each quarter he must send a copy of this account to the inspector...

84. In case of any wrecks taking place in the vicinity of a light-ship, the master must, if possible, learn whether the light was seen by anyone on board the wrecked vessel, and whether it was recognized, and how long it was seen before the vessel struck.

85. A book containing an account of the vessels passing the light-vessel must be kept.

86. The master must see that the watch is set and everything in order before leaving the deck at night.

87. A regular watch must be kept at all times. The pump well must be sounded at least once during any watch at night, and in bad weather, every hour. In case the light-vessel makes more water than usual, the fact must be reported at once to the master.

88. Fire buckets must be kept on deck in the most convenient place for use, and when the temperature will permit, filled with water at sunset every day. They are on no account to be kept between decks at night...

94. In bad weather the master must give constant personal attendance to the affairs of the ship; he must see the spare anchor kept ready for letting go, and a proper range of cable on deck, bitted and stoppered to bring the vessel up in case she drags; and a sufficient watch must be kept to meet any emergency.

95. The deep-sea lead must be kept overboard in heavy weather, and a hand stationed by it whenever there is danger of the vessel dragging; should she drag such a distance as to deceive passing vessels in regard to their position, the lights must be extinguished and day marks carefully concealed.

96. Under no circumstances, except those of extreme and imminent danger, shall the master permit the vessel to be moved from her proper station.

97. The inboard end of the chains shall be passed twice around the foremast at the keelson, and then lashed to an eye or ring bolt provided for the purpose.

98. Every month the riding chain must be hove in, until the point where it is shackled to the bridle is above water; the chain must then be carefully examined and its condition noted in the log.

99. Masters must be careful to vary the scope of chain according to the weather; in mild, smooth weather the chain must be hove in to a moderate scope; in heavy and tempestuous weather, and in gales, it must be veered to its full scope...

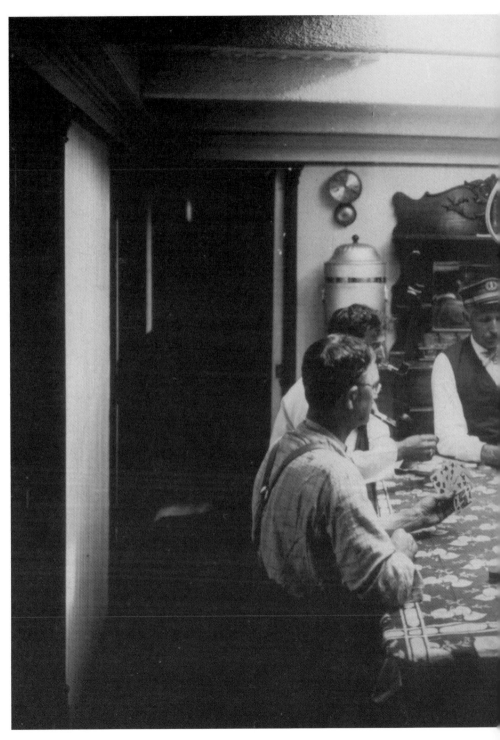

The crew, occupied before television was available. *Courtesy of the United States Coast Guard.*

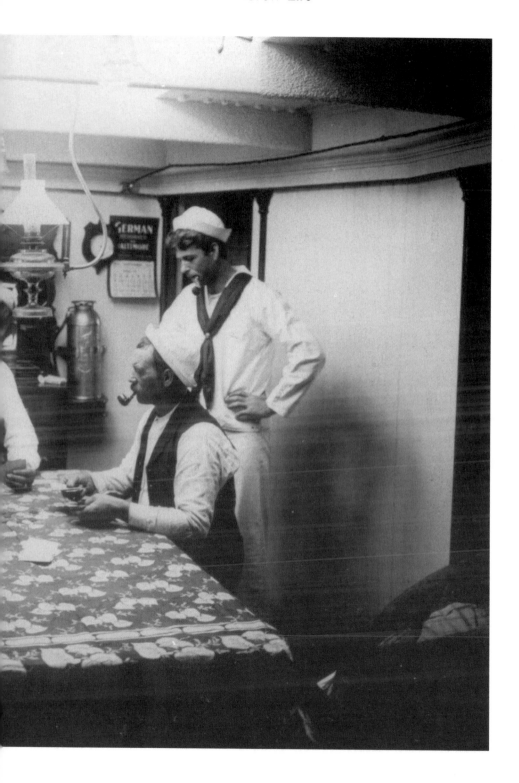

102. The ballast must be moved and the hold thoroughly cleaned out at least once in six months.

103. The vessel must be pumped out daily; any water which can not be removed by the pumps must be bailed out with buckets and swabs. Every precaution must be taken to keep the vessel well ventilated; wind sails must be kept up in summer. In hot weather, awnings must be spread to keep the vessel cool between decks.

104. Wet clothing or wet bedding must not be kept below; once a week all bedding must be carefully aired in summer, and at least once a month in winter.

105. During the stormy season sails must be kept bent; they must be frequently loosed to dry when the weather will permit.

106. Great care must be taken of the boats and their equipments. They shall not be used for the personal convenience or profit of the masters or crew in ferrying passengers, freighting, or wrecking; they shall not, under any pretense, be detained on shore, or when alongside of a vessel remain in water for a longer time than may be absolutely necessary. When not in use they shall be kept hoisted to the davits, and at night and during stormy weather swung inboard. They shall be kept free of water, and have all ballast and stores removed before being hoisted up and secured. Masters shall be held accountable for loss of, or damage to, the boats while absent by their order.

107. Prompt information must be sent to the inspector when there is danger that supplies or stores will run short.

108. The master is prohibited from carrying on any trade or business whatever which will take him from the light-vessel, or in any way cause him to neglect his public duties. Nothing whatever shall be kept for sale on board the light-vessel.

109. No malt, vinous, or spirituous liquors must be kept or used on board of any light-vessel, except those belonging to the medicine chest, which must be reserved for cases of actual illness.

110. The master must hail all vessels which by hovering too near the light-vessel may prevent the lights from being seen, and request them to keep off. Under no circumstances shall he permit any vessel to make fast to the light-vessel.

111. Persons not belonging to light-vessels (the officers, crew, and passengers of wrecked vessels who may be compelled to take temporary refuge on board excepted) shall not live on board, or remain at night, unless necessarily detained by stress of weather.

112. Masters shall not permit the vessels under their charge to be made a rendezvous for pilots; every proper courtesy must be shown pilots, as well as

all other persons, but no undue use of the light-vessels or their boats shall be permitted to anyone.

113. The master and mate are prohibited from being absent from the ship at the same time; one of the two must always be on board.

114. Crews of light-vessels will be allowed all reasonable and proper indulgences in visiting their friends and families ashore. During the milder seasons of the year, two of the crew, besides the master or mate, may be ashore at a time, if the ship carries a complement of eight persons all told. If but six persons or less are attached to the ship, one only, beside the master or mate, may be allowed to be absent. During the stormy seasons of the year, one only of the crew, in either case, shall be absent, and if the season is especially tempestuous, all hands must remain aboard as a rule; short absences only being allowed under such circumstances. Any abuse of these privileges on the part of anyone must be promptly reported to the inspector by the master...

116. Masters, mates, and crews are all required to live and mess on board the light-vessel to which they are attached...

120. Whenever a light-vessel leaves her station for any cause the master shall use all available means to report the fact to the inspector...

122. The following-named returns shall be made by masters of light-vessels to the Inspector:

Monthly Mooring reports.
Fog-signal reports.
Report of absences.
Pay roll (to be sent in at least one week before the end of the month).
Quarterly Expenditures of oil, etc.
Muster roll.
Abstract of passing vessels.
Annually Description and inventory of vessels.

123. Lights must be lighted punctually at sunset, and must be kept burning at full intensity until sunrise.

124. All preparations must be made early, that there may be no delay in lighting.

125. When the light is extinguished in the morning the keeper must hang the lantern curtains and immediately begin to put the apparatus in order for relighting. While doing this the linen aprons provided for the keeper's use must be worn, that the lens may not suffer from contact with the wearing apparel. The illuminating apparatus must be carefully covered before the cleaning is begun.

126. The lens and the glass of the lantern must be cleaned daily and always kept in the best possible condition. Before beginning to clean the lens it must be brushed with the feather brush to remove all dust. It must then be wiped with a soft linen cloth, and finally polished with buff-skin. If there is oil or grease on any part it must be taken off with a linen cloth, moistened with spirits of wine, and then polished with a buff-skin. Under no circumstances must a skin which has been wet or damp be used, as this will scratch the lens...

233. The keepers of stations provided with fog signals will be held to a strict accountability for the proper care, attention to, and management of fog signals.

In these earlier times, sail and steam power were inadequate in providing relief from heavy seas. The rolling and pitching of the ship under such conditions was more severe, and the incidents of being blown off station were more frequent than in the later years of lightship duty. Eventually, the lightships became larger and more stable and greater relief was possible from the worst of a storm's effects. The crew's life improved with the advent of wider bunks and more frequent rotations. But the ever-present dangers of collision and the constant battering during fierce storms did not change. In the early days of the twentieth century, at Diamond Shoal, the most difficult and dangerous American lightship station, there was a major and long-lasting storm. Frederick Talbot tells the following story about this storm:

When these adversities are aggravated by the relief-boat being unable to fulfill its scheduled duty, when week after week slips by without the men receiving the welcome spell ashore, while they are suffering privations and experiencing nerve-shattering pangs of isolation and monotony, it is not surprising that despondence shows signs of getting the upper hand among the crew. Melancholia is the malady which is feared most on a light-vessel such as this, and the men have to pull themselves together to resist its insidious grip. Probably at times there is half an inclination to desert the light but there is little fear of this temptation succeeding. The axiom: "Never abandon the light" is too deeply rooted; besides the men are safer where they are, although it appears a crazy refuge in rough weather.

Prolonged imprisonment on the lightship Diamond Shoals precipitated one mutiny. The crew on duty was awaiting the arrival of the reserve vessel to take them home; but the weather disposed otherwise. With that inexplicable persistence, the wind got round to a rough quarter and kept there tenaciously, never moderating for a few hours, but just blowing and

blowing, getting up a nasty sea which made the lightship reel and tumble, while at intervals a comber came aboard to flush the decks.

In the course of ten days or so the crew began to fret and fume at the obstinacy of the elements; when a month slipped by without bringing any welcome relief, the mate and the engineer incurred the captain's dire displeasure by fraternizing and playing cards with the crew, thereby creating a breach of discipline and etiquette. The offenders somewhat overwrought by their continued incarceration ignored the captain's reprimand. This arrant disobedience played upon his nerves, which similarly were strung up. It did not require a very big spark to start a conflagration of tempers. The mate and the engineer brooded over the captain's remarks, and at last they waited upon him, forcibly ventilated their opinions concerning his lack of civility under the trying circumstances and expressed their determination to tolerate his overbearing manner no longer. This was the last straw from the captain's point of view. Drawing his revolver, he growled that he was master of this lightship and that they would have to do as he told them. There was a tussle, but the firearm was wrenched away from the master's hands as being a somewhat too dangerous tool for a man in his over strung condition. The crew naturally sided with the officers, and the captain was kept under surveillance until the relief vessel came up some weeks later.

The moment the crew stepped on dry land, every man with the exception of the mate, deserted the ship, thoroughly satiated with the uncertainty pertaining to watching the Diamond Shoals. They indulged in a hearty carousal, and were arrested. And the captain, who also was not averse to enjoyment on the shore, having lodged a charge of mutiny, followed their example. An inquiry was held and the sequel is interesting. The captain, having deserted his ship upon reaching port, was dismissed from the service; the mate, who had provoked the captain, not only was acquitted of the grave charge, but was promoted to command of the light-vessel, because there was one outstanding feature in his favor which negated everything else—he had stuck to his post.

The life did have its perilous moments, facing storms and near collisions, but on these ships, it was typically like most military duty—hours of boredom followed by moments of sheer panic. To be sure, there was work to be done maintaining the ship and its apparatus, but the weather—storms, fog, ice—and the ever-present danger of collision provided the excitement.

Surviving lightship sailors report that the duty was satisfying, the food was good to excellent and morale was high. The routine called for spending about eight months each year on the ship. In the early days a tour was four months on and two months off. In more modern times the duty schedule

The crew aboard WLV *605* at Overfalls station November 1945. Joe, Herm, Skip, Bob and John. *Courtesy of the Overfalls Maritime Museum Foundation.*

was two weeks on and one week off. This routine was possible if the weather permitted the tender to make its scheduled trips. Even the more modern lightships rolled and heaved in heavy seas to a far greater extent than a moving ship. The force of wind and waves moved the ship against the anchor, pulling the bow under as it reached the length of the anchor chain. Some relief was possible by running the ship's engines against the seas to provide some stability. But, no matter how fair the weather, an even keel only lasted for a few moments before the next sudden roll occurred. Over the years, modern lightship duty improved and crews were somewhat spared from the harsher life experienced by their predecessors. As the service evolved there developed a high standard of professionalism and a history of dedication to the interest of mariners.

Chapter 8

Outside Lightships—Going South

CAPE CHARLES/CHESAPEAKE, VIRGINIA

Moving south along the Atlantic Coast, the next lightship position marks the approach to the Chesapeake Bay. From its original position established in 1888, the Cape Charles station was relocated several times because ships were being built with a deeper draft and there were improvements in other navigational marking systems. The six lightships that served this station were moved off their position nine times by the weather. The first ship, LV *46*, was a schooner built for the station, which was then designated as Cape Charles. After three years at Cape Charles, this ship served on five other stations, starting at the Overfalls, before being sold in 1923.

The next twenty-five years were covered by LV *49*. Built in Boston, Massachusetts, in 1891, the ship was a 121-foot schooner, displacing 470 tons. It carried two lanterns, each with eight reflecting oil lamps. It had a steam whistle and a thousand-pound bell for use during periods of poor visibility. Weather caused this ship to break adrift seven times during its tenure, once picked up sixteen miles off station and towed into Hampton Roads, Virginia, by the USS *Columbia*. Other troubles included being rammed by the steamer SS *Grayson* on December 18, 1912. The importance of this station is emphasized by an 1898 record indicating 3,268 steamers, ten ships, forty-five barks, eight brigs and 7,950 schooners—a total of 11,271 ships—passed by the station that year. After being relieved, this lightship went on to several other positions in the Massachusetts region until it was retired at the age of fifty in 1940.

Between 1916 and 1933 three different vessels served on this station: LV *101* until 1924, LV *80* until 1927 and LV *72* until 1933. The first of these, LV *101*, went on to serve at several other stations, including twenty-five years at the Overfalls, before it was retired and became a museum in Portsmouth, Virginia. One of the unique features of this vessel was the large diameter tubular mast, which had an interior ladder allowing the crew to work on the lighting apparatus from the inside.

LV *80* was a steam-propelled, 129-foot ship, displacing 668 tons. It was one of the five sister ships built in 1904 by New York Ship Building in Camden, New Jersey. Its illuminating apparatus had been changed from oil to acetylene and later to electricity by the time it was assigned to Cape Charles. Following this assignment from 1924 to 1927, the ship served as a relief vessel until it was finally sold in 1934.

In 1928 the station was renamed "Chesapeake," and another steam-propelled, steel-hulled vessel, LV *72*, took up the duty after serving twenty-two years on Diamond Shoal and five years as a relief ship. This 123-foot lightship carried a 375-mm electric lens lantern at each masthead, a twelve-inch steam chime whistle and a hand-operated thousand-pound bell. By the time the craft was assigned to this station, it had been equipped with a submarine bell, a radio and a radio beacon. Sent to Cross Rip, Massachusetts, in 1934, LV *72* was retired and sold in 1937.

The last vessel serving on this station was LV *116*, one of six diesel-electric-powered sister ships built in 1930. Each was 133 feet in length and displaced 630 tons. The equipment consisted of a 375-mm electric lens lantern at each masthead, an electric diaphragm horn and a hand-operated bell. During World War II, this station was marked with a buoy, and the lightship served as an examination vessel off the northern entrance of Cape Cod Canal. She was armed with two 20-mm guns. After the war, LV *116* returned to the Chesapeake station.

In 1964 the light was listed as a duplex 375-mm lens lantern on the foremast with 13,000-candlepower for each lamp. Its other equipment included a radio, a radio beacon and radar. The next year the lightship was replaced by a light tower about four miles north of her final location. Later, after being the last ship on the Delaware station, this vessel was retired in 1970 and given to the National Park Service. Today it is at the Maritime Museum in Baltimore's Inner Harbor.

Three "outside" stations were located along the North Carolina coast: the Diamond Shoal, Cape Lookout and Frying Pan Shoal. These all sit east of a group of barrier islands that separate the Atlantic Ocean from Pamlico Sound.

DIAMOND SHOALS, NORTH CAROLINA

One of these stations is located at the most dangerous part of the coast, the Cape Hatteras region. This is the dreaded Diamond Shoals, reaching almost thirteen miles seaward, with the Labrador Current flowing south and a strong ocean current, the warm Gulf Stream, flowing north just a short distance farther east. This leaves a narrow path for navigation and,

LV *101*, which also sat on the Charles/Chesapeake station. *Courtesy of the United States Coast Guard.*

when the storms common to the region occur, they make this a treacherous passage. Hurricanes and northeasters overpower ships with their strong winds and heavy seas, sometimes forcing them ashore to be battered apart by the crashing breakers. The area is a storm center with a flurry of gales during a northeast or southeast wind, but it is also the direct route of all north and south coastal trade and is passed by many vessels between the southern ports and northern Europe. The region is one of the ship graveyards of the Atlantic coast. The first known wreck occurred June 15, 1585. It was the *Tiger*, a British ship of Grenville's expedition. The records of the seventeenth and eighteenth centuries show losses of hundreds of craft of all sorts including several craft of war and the ironclad, *Monitor.*

The government tried many things to warn mariners of these dangerous waters. Lighthouses were planned and some built only to have their foundations washed away. Fog and bell buoys met the same fate so finally lightships were chosen to mark this spot.

Alexander Hamilton, in a 1794 report to the Senate, advised Congress to erect a lighthouse on some part of Cape Hatteras. As a result, a lighthouse

ninety feet tall was built between 1798 and 1803. The light was not particularly effective and, to improve the mariner's safety, a vessel named *Cape Hatteras* was placed on the station in 1824. The location of this station was about fifteen miles southeast of the recently built Cape Hatteras light. This ship lasted about three years before being beached near Ocracoke Inlet one night during a northeaster. Other options were tried—a bell boat, a buoy, a whistling buoy, a gas buoy—but all disappeared after a short time.

The lighthouse had a first-order Fresnel lens installed in 1854, improving the light's visibility. After the Civil War, the current 208-foot-tall lighthouse was built, replacing the original one. This was an improvement but still not sufficient for real safety.

On November 24, 1877, the United States sloop-of-war *Huron* was wrecked in the area. Out of a crew of 130, only 4 officers and 30 sailors were rescued. Another major attempt was made to build a lighthouse out on these shoals. A large caisson was built in Norfolk, Virginia. It was fifty-four feet in diameter and forty-five feet high. After the caisson was towed to the site and sunk in twenty-five feet of water, the soft seabed and strong currents ruined the operation. The caisson was smashed to fragments, and the project was abandoned. The remaining funding was diverted to the building of a new lightship, LV *69*, which marked the station on September 30, 1897.

This new lightship was built by the Bath Iron Works in Maine, utilizing the lighthouse's Congressional appropriation. It was a 590-ton, 123-foot ship, with a steel frame and wood hull, powered by steam but also rigged for sail. The vessel was equipped, when launched, with three 100-candlepower, electric lens lanterns at each masthead, a steam whistle and a hand-operated bell. This Diamond Shoals lightship was anchored in the open Atlantic Ocean thirteen miles off Cape Hatteras, making it the most exposed and dangerous American lightship station of its time. Its duty was to guide ships clear of the dangerous shoals that extended off the cape.

During the year 1899, over five thousand vessels were recorded passing by the lightship. It was, however, dragged off station by storms five times and on August 18 of that year, a hurricane drove the ship ashore and stranded it on a beach near Cape Hatteras. All hands were saved and the vessel was floated again on September 20, 1899.

This craft alternated with its sister ship, LV *71*, until reassigned to the Overfalls station in 1901. LV *71* continued to alternate at three-month intervals on Diamond Shoals until 1918. During that time it was equipped with a wireless telegraph in 1904 and had its lighting apparatus changed several times. When not on Diamond Shoals, the vessel served as relief at several other east coast stations.

LV *116*, the last vessel on the Chesapeake station. *Courtesy of the United States Coast Guard.*

The alternate vessel during this period was LV *72*, built in 1900. A heavier vessel at almost seven hundred tons, using steam for propulsion, it carried about the same equipment as LV *71*. While not on Diamond Shoals, it too relieved at various eastern posts. Permanently removed from this post in 1922, the ship also served as a relief on several other stations, including Cape Charles, before being sold in 1937.

On August 6, 1918, after broadcasting the presence of a German submarine that had sunk a passing freighter, the lightship LV *71* itself became a target. Fregattenkapitan Waldemar Kophamel had his submarine, *U-104*, fire six surface shots at the lightship. Two of these hit the vessel's port side. So alerted, the crew took to their lifeboats and rowed safely to shore with no injuries. Later the U-boat returned and took seven more shots to sink the lightship. The wireless message broadcast by the lightship that so enraged the German commander, is reported to have caused about twenty-five merchant vessels to take refuge, thereby not becoming U-boat targets.

The next vessel assigned to Diamond Shoals, LV *105*, was, at the time, the largest and most modern lightship in the United States. It was 146 feet long and displaced 825 tons. A steam vessel with a steel hull, it was equipped with a radio and a radio beacon when built. Within a year the lightship had its acetylene lamps changed to electric. It went on station September 1, 1922, and over several years steamed the equivalent of three hundred miles while moored to prevent dragging the anchor.

The Diamond Shoals ship had a terrifying experience during the hurricane of September 1933. The center of this storm touched the coast at Cape Hatteras, and then moved out into the Atlantic. The unusual movement of the storm subjected the vessel to conditions probably seldom experienced by a lightship.

While under power to maintain its station it dragged the 5,500-pound anchor and 24,000 pounds of chain five miles from the lightship station onto the breakers at the edge of the Diamond Shoals. The ship sustained some damage to its topsides but took advantage of the lower winds during the eye of the hurricane to drop the mooring equipment and move outside the shoal area. Later the lightship was able to institute radio communication and established their location as about sixty miles east-northeast of the Cape Hatteras lighthouse and later at about 110 miles southeast of Cape Henry.

This ship survived several other major hurricanes before it was removed during World War II for use as an examination vessel. It was during this service that it was rammed and sunk at Portsmouth, Virginia, on July 20, 1944.

After the war, LV *114* covered the post for two years until 1947. This was one of the six diesel-electric-powered ships built in 1930. This vessel

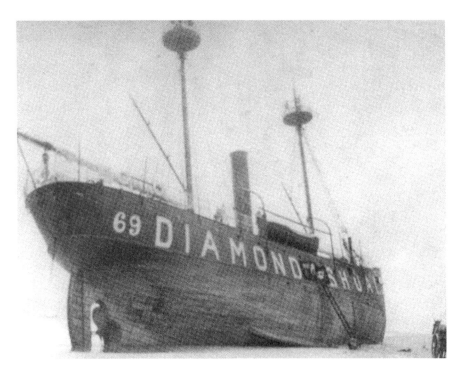

LV *69*, grounded after the hurricane of August 18, 1899. *Courtesy of the United States Coast Guard.*

was built in Oregon and was the first lightship to make the west to east trip through the Panama Canal. It carried a 375-mm electric lens lantern on each of its two masts and had an air diaphone and a hand-operated bell. After serving at several East Coast stations, the vessel was retired in 1971 and transferred to the city of New Bedford, Massachusetts.

The final ship to sit at this post was WLV *189* built by the coast guard specifically for Diamond Shoals in 1946. This vessel was replaced by the Diamond Shoals Light Tower in 1966. It then went on to serve two years at New Orleans, two years at Five Fathom Bank, followed by three years at the Boston station. When retired in 1975, it was donated to Atlantic City, New Jersey, for use as a museum.

CAPE LOOKOUT SHOALS, NORTH CAROLINA

Continuing down the coast, the next lightship station was almost one hundred miles southwest of Cape Hatteras at Cape Lookout Shoals. Here again there are shoals extending more than nine miles off the shoreline and the lightship marks safe passage for coastwise traffic. It also marks the entrance to Beaufort Inlet. This station operated for only twenty-eight years, from 1905 until 1933,

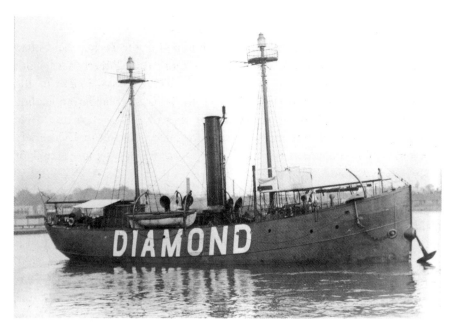

LV *71* before it was sunk by a German submarine in 1918. *Courtesy of the United States Coast Guard.*

when it was marked by a lighted bell buoy. LV *80* manned the post from its establishment until it was replaced in 1924. Displacing 668 tons, this 129-foot lightship was built in Camden, New Jersey. It was delivered to the Lighthouse Bureau's Lazaretto Depot in Baltimore on December 1, 1904. Funds, however, did not become available to place it on station until the beginning of April the next year. The ship was steam-powered but also rigged for sail. It carried a steam whistle and hand-operated bell. The illuminating apparatus consisted of a cluster of three oil lenses raised to each masthead. Oil was replaced by acetylene in 1922. The vessel was blown off station a number of times and once, on February 24, 1914, the master boarded the steamer *Cretan* and sent a radio message requesting new moorings. In 1918 the lightship was finally equipped with a radio. This vessel spent a few years at Cape Charles before being used as a relief vessel until it was sold in 1934.

The final nine years of this station's operation were the responsibility of LV *107* on its first posting. This steam-propelled vessel was equipped with a steam whistle, a submarine bell, a hand-operated bell and a 375-mm electric lens lantern on each masthead. It came with a radio and radio beacon when built in 1923. It also had several bouts with the weather before being reassigned to the Winter Quarter Shoal.

FRYING PAN SHOAL, NORTH CAROLINA

For 110 years a lightship station was maintained at the Frying Pan Shoal. Located off Cape Fear, this shoal extends more than fifteen miles south and east of the shore. This station showed the safe passage clear of the shoal area and also marked the approach to the Cape Fear River, leading to Southport and Wilmington, North Carolina. Records show that nine different ships served here, some more than once. Starting in 1854, there was a lightship and all that is known about it is that it was removed, sunk or destroyed by Confederate forces in 1860.

In 1863 after being vacant for three years, the station was occupied by LV 32. This was a hundred-foot wooden sailboat built for this specific location. It carried two lanterns, each holding eight lard-oil lamps. Plagued with leaking problems and frequent bouts with the weather, the ship was replaced after one year but later returned to serve again from 1877 through 1883. The replacement was LV 29, another small wooden sailing vessel of 232 tons. It also carried two lanterns, each with eight oil lamps and reflectors. This lightship's first shift was between 1865 and 1871. The ship then returned between 1875 and 1877 and also 1888 to 1892. LV 34 took the four years between 1871 and 1875. This was another wooden sailboat, 101 feet in length, displacing just over 200 tons and carrying two lanterns, each with eight fountain-burner oil lamps and a hand-operated bell.

The modern era started with the acquisition of LV 53 in 1892. This was one of four sister ships built in Bay City, Michigan. They had iron hulls and steam propulsion (but were also rigged for sail) and were the first lightships to have the hawsepipe through the stem of the vessel, aligning it with the centerline. This ship carried two lanterns, each with eight oil lamps and reflectors. After surviving several hurricanes, this ship was moved to a station closer to Charleston, South Carolina, where there were adequate marine railway facilities available for repair work.

After thirty-six years on the Nantucket New South Shoal station and four years in South Carolina, LV 1 received this assignment. Originally this was another wooden sailing vessel carrying two lanterns, each with eight oil lamps and reflectors. It had, however, been rebuilt in 1892: a boiler, steam pump, steam windlass and a steam fog whistle were installed. In 1901 a comparison of seven years worth of maintenance costs between the wooden LV 1 and iron LV 53 showed that the iron vessel was less expensive to maintain even though it needed more frequent hauling for chipping and painting.

After five years, this vessel was replaced by LV 94 in 1911. Almost 136 feet long and displacing 660 tons, this steel-hulled, steam-powered vessel was reported to be the most highly developed lightship in the fleet. It had

a steam whistle, a submarine bell and a hand-operated bell. The lighting apparatus consisted of a 6.5-foot lantern housing and a fourth-order lens on a compound pendulum that was mounted in gimbals 68 feet above water level.

In 1930 the position was moved about fourteen miles southeast and LV *115* was assigned. This was one of the six diesel-electric-powered lightships built in 1930. It had an electric diaphragm horn using a mushroom trumpet and carried a 375-mm electric lens lantern at each masthead. With time out as an examination vessel during World War II, this ship served Frying Pan until it was replaced by a Texas tower in 1964. The ship became a museum in Southport, North Carolina, but was sold in 1984. It was moved to the Chesapeake Bay where it sank. Later raised and re-powered, it was moved to New York City.

Chapter 9

The End of an Era

Lightships, or floating lighthouses, were an essential part of the U.S. government's commitment to safe navigation on America's waterways. Between the years 1820 and 1950, federal authorities built or otherwise acquired 179 of these ships. This review looked at 85 of these vessels that served on the forty-five stations located along the mid-Atlantic coast and the area's bays and sounds.

Between 1820 and 1854, the first twenty-six ships built for the region were constructed as the need arose and at the direction of local officials. The records show that nine of these were removed, sunk or destroyed by Confederate forces. Made of wood, the remaining seventeen were probably damaged by worms, rotted or were abandoned to nature.

By 1950 there were 120 vessels that were identified by the numbering system started in 1867. Of these, 59 are included in this study. Records indicate the disposition of all but 4 of these ships. Reportedly, 27 were sold, most before 1930. The coast guard record ceases with the sale of these ships but it is possible that some of them still exist in some capacity.

Other ships had more interesting endings, and, in many cases, one that was final. The U.S. Navy sank two as targets for gun and torpedo practice in the latter years of the nineteenth century.

The Agency for International Development gave LV *106* to Suriname to be used as a lightship and recently it was reported to be decaying in the Suriname River.

A Massachusetts Sea Scout unit was the recipient of LV *1*, the wooden schooner retired in 1930 after seventy-five years of service. It was grounded and abandoned after a flood in 1936.

One ship, LV *20*, which once marked the Wreck of Scotland and the Wreck of Oregon stations, was reportedly used by rumrunners as a warehouse during Prohibition and was later burned as a Fourth of July bonfire.

LV *53* from Frying Pan Shoal was sold September 15, 1951. All that remains is the lantern mast and a large-diameter lantern housing which marks the parking lot of the American Grill in Yardville, New Jersey.

WLV *189*, a veteran of both Diamond Shoal and Five Fathom Bank, was used for several years as a floating display in Atlantic City, New Jersey. It was scuttled off that coast in 1994 to form an artificial reef.

A number of vessels were lost while on duty. The first U.S. lightship sunk on station was LV *17*. This happened at Five Fathom Bank during a hurricane on August 24, 1893.

Ten years after LV *51* left Sandy Hook, a collision on April 24, 1919, caused its sinking while it relieved at Cornfield Point, Connecticut.

During World War II, a number of lightships were used as examination vessels, helping in various ways with coastal defense. LV *105* was one of these stationed at Portsmouth, Virginia. While on this duty she was rammed and sunk on July 20, 1944. There are no other details given in the record.

Today only a few lightships remain. There are three "Nantuckets" still afloat. LV *112* is docked at the public wharf in Oyster Bay, New York. Several nonprofit organizations have owned this vessel since its retirement in 1975, including the Intrepid Sea Air Space Museum in New York City and the HMS Rose Foundation located in Bridgeport, Connecticut. The present owners, the National Lightship Museum, acquired it to become the flagship of their Staten Island Museum. There is some indication today that this museum may not be developed. The ship currently awaits a nonprofit organization to step forward and provide it a home.

WAL *612* and WAL *613* are privately owned. The first of these two Nantuckets was the last lightship in service when it was retired March 29, 1985. It was sold to the Boston Marine Exchange, an educational organization. Low funding soon caused the ship to be returned to the General Services Administration. The Commonwealth of Massachusetts then purchased the vessel to be a floating museum, but these plans also fell through. The ship was bought by a private party who, after refurbishing it as a yacht, hoped to operate it as a time-share business in Nantucket Harbor during the summer and a party boat out of Boston at other times. These ideas have not worked out quite as planned and the vessel was seen at City Pier in New Bedford, Massachusetts, in October 2006.

WAL *613*, a sister ship also serving on the Nantucket station, was sold to the New England Historic Seaport also intending to use it as a floating museum in Boston. Today it is owned by the Wareham Steamship Corporation and it is berthed in Wareham, Massachusetts.

A real adventure involves WAL *537*, known today as the *Frying Pan*. After being decommissioned November 4, 1965, it became a museum

What is left of LV *53. Courtesy of the author.*

at Southport, North Carolina. In 1984 it was sold and moved to the Chesapeake Bay, where it sank in 1986. It was raised the next year, painted and provided with a smaller engine. Because of its inadequate power it was not allowed to travel the Chesapeake and Delaware Canal and, while still in the Chesapeake Bay, it suffered a fire in 1988. New owners re-powered the vessel and, after a stay in Philadelphia, were able in 1989 to get the ship to Manhattan where it sits at Pier 66 at West 26th Street. Today it is a party boat and described as one of the city's best places for festivities.

There are three more surviving lightships whose futures are in doubt. The oldest of these is LV *79*, the *Barnegat*. Retired in 1967 after fifty-four years of service, it was donated to the Chesapeake Maritime Museum where it remained until 1975. At this time the museum decided to release the vessel as it was not directly associated with the history of the Chesapeake region.

The Heritage Ship Guild took the vessel as part of their display at Penns Landing in Philadelphia. They were unable to afford the expenses, particularly those needed to repair the pitting of the hull at the waterline, and the vessel was delivered to a boat junkyard, Pyne Poynt Marina in Camden, New Jersey. The lightship sits on the bottom with her bilge flooded and in very poor shape overall. This ship does not appear to have a very encouraging future.

LV *107* also had an adventurous life after retirement. This ship served, among others, both the Winter Quarter and the Delaware stations. When it was retired in 1968, it was transferred to become a museum in Hampton, Virginia. A hulk was sighted there in 1980, and in 1984 the vessel was reported to be at a ship-breaking yard in Bordentown, New Jersey. The craft was rescued and became a bar and grill at Liberty Landing Marina in the Liberty Landing State Park, Jersey City, New Jersey. The park is still growing and they have added a restaurant whose competition caused the bar and grill on the lightship to close. Today the ship is used as marina offices and includes a sailing school. As the park continues to develop the ship's offices may become redundant.

Perhaps the saddest of all these stories concerns the New Bedford, LV *114*. This ship was given to the city of New Bedford, Massachusetts, in 1975 and it was added to the National Register of Historic Places in 1980. After sitting for more than thirty years almost unattended, the vessel sprung a leak and rolled on its side June 1, 2006. The city, after spending more than $200,000 raising the ship, tried to auction it September 26, 2006, but there were no bidders. This ship was scrapped in July 2007.

Of the 179 total American lightships, only 19 survive. Of these, 7 are open to the public as museums. There are 4 on the East Coast, 1 on the Great Lakes and 2 on the West Coast.

The End of an Era

The *Ambrose*, LV *87*, rests in New York City. Built in 1907, it is one of the exhibits at the South Street Seaport in Manhattan.

Portsmouth, Virginia, displays the *Portsmouth*, LV *101*, built in 1918. It adjoins the Portsmouth Naval Shipyard Museum. The name is a pseudonym, as there was never a Portsmouth station. This vessel spent twenty-five years of its career at the Overfalls station.

The Overfalls Maritime Museum Foundation, Lewes, Delaware, hosts the *Overfalls*, LV *118*, which was built in 1938. This vessel was stationed several places in New England and ended its active career as the Boston lightship. In recent times, this vessel has undergone a major restoration and welcomes many visitors each year. It has carried the name *Overfalls* longer than any other ship although it was never stationed on the Overfalls Shoal. Both the vessel on display at Portsmouth and WLV *605* now in Oakland, California, served on this station.

The *Chesapeake*, LV *116*, resides in Baltimore, Maryland. This ship was built in 1930 and served off the Delaware Coast and at the mouth of the Chesapeake Bay. It is one of several ships on display at the Baltimore Maritime Museum.

The only known surviving Great Lakes lightship open to the public is the *Huron*, LV *103*, an exhibit at the Port Huron Museum in Michigan. It is the only lightship with a black hull.

In Astoria, Oregon, is the *Columbia*, WLV *604*, built in 1950 and retired in 1979. It is now an exhibit of the Columbia River Maritime Museum and open for the public to tour.

A ship called *Relief*, WLV *605*, serves as a floating museum docked at Jack London Square in Oakland, California. This was the last ship to serve on the Overfalls station, after which it was transferred to and served on the West Coast. Built in 1950, the vessel was decommissioned January 1, 1976. After several owners the ship was ultimately acquired in December 1986, by the U.S. Lighthouse Society.

Currently undergoing a major renovation so it can take its place as one of the lightship museums is the *Swiftsure*, LV *83*. It was built in 1904 and now is part of the collection of landmark vessels at the Northwest Seaport in Seattle, Washington.

Some other vessels are in private hands including LV *75*, located in a Staten Island, New York, shipyard where plans call for it to be restored. WLV *196* was retired in 1971 after twenty-five years of service and is now sitting in a cove at Pennock Island near Ketchikan, Alaska, and renamed the *Marine Bio Researcher*. Also reported to be in Alaska is LV *102*, used as a crab-processing plant in Seattle, Washington, after forty-six years of lightship service in the Gulf of Mexico and New England waters. It was listed as the

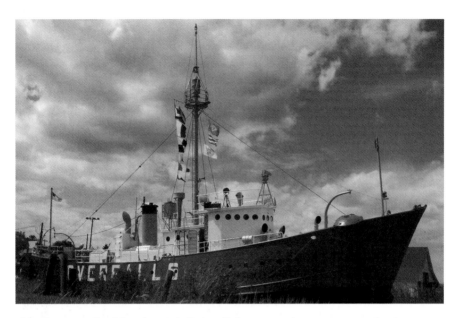

LV *118*, today's *Overfalls* as it rests in Lewes, Delaware, serving as a museum for those interested in this part of maritime history. *Courtesy of the author.*

fishing vessel *Big Dipper* in 1970. More recent information suggests that it has been renamed the *Jamie Lynn* and that it may be fishing out of the town of Metlakatla, Alaska.

For 165 years lightships were used as an aid to navigation where the safety of mariners was paramount and there was no alternative. As the lightships themselves developed, their use increased until their numbers peaked in the early twentieth century. At the time light technology—the lamps, the fuel and the lenses—were all improving. Ways were found to provide the same, and in many cases better, safety for those using the sea lanes. The development and use of screw-pile lighthouses, of radio and radio beacons, lighted buoys, modern automated beacons and finally Texas towers led to the obsolescence of the lightship in American waters. For example, in 1972, the Five Fathom Bank lightship was replaced by a large navigational buoy.

The nineteenth and early twentieth century was a time of great growth and development in America and the lightship played a significant part in keeping our maritime commerce safe. This same technological development, however, ended the need for both manned lighthouses and lightships.

Those who love the lore and legends of the sea tend to believe that the few lightships that are left should be preserved, as lighthouses are currently being preserved. Significant artifacts from our nation's early maritime history, they help keep these memories alive for the next generations.

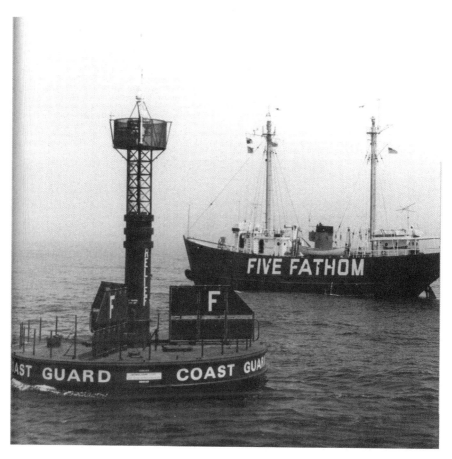

LV *189* as it was replaced by a large navigational buoy in 1971. *Courtesy of the United States Coast Guard.*

Lightship Stations and the Ships That Served Them

#	STATION NAME	LATITUDE	LONGITUDE	YEARS	SHIPS ASSIGNED	YEARS
7	Nantucket Shoals, MA	40° 56.5'N	69°51.5'W	1854–1884	LV 11	1854–1855
		40° 54.9'N	69°49.4'W	1884–1892	LV 1	1856–1892
		40° 46.0'N	69°56.0'W	1892–1896	LV 54	1892–1894
		40° 37.0'N	69°37.1'W	1896–1946	LV 58	1894–1896
					LV 66	1896–1907
					LV 85	1907–1923
					LV 106	1923–1931
		40° 37.0'N	69°18.5'W	1946–1955	LV 112*	1936–1958
		40° 30.0'N	69°28.0'W	1955–1983	LV 196	1958–1960
					LV 112	1960–1975
					WLV 612	1975–1983
					WLV 613	1975–1983
24	Fire Island, NY	40° 28.3'N	73° 11.3W	1896–1898	LV 58	1896–1897
		40° 28.7'N	73° 11.4W	1898–1942	LV 85	1897–1930
					LV 114	1930–1942
25	Wreck of Oregon, NY**	40° 33.0'N	72° 51.0'W	1886–1886	LV 20	1886–1886
26	Sandy Hook, NY	40° 26.0'N	73° 52.0'W	1823–1829	V V	1823–1829
	Ambrose, NY				(vacant)	1829–1838
		40° 26.9'N	73° 52.0'W	1839–1891	W W	1839–1854
					LV 16	1854–1891
		40° 26.2'N	73° 51.7'W	1891–1894	LV 48	1891–1894
		40° 28.3'N	73° 50.2'W	1894–1902	LV 51	1894–1908

#	STATION NAME	LATITUDE	LONGITUDE	YEARS	SHIPS ASSIGNED	YEARS
		40° 28.0'N	73° 50.0'W	1902–1929	LV 87	1908–1932
		40° 27.1'N	73° 04.4'W	1929–1967	LV 111	1932–1952
					WLV 613	1952–1967
27	Scotland, NY	40° 27.0'N	73° 56.0'W	1868–1870	LV 20	1868–1870
					(vacant)	1870–1874
		40° 26.4'N	73° 55.9'W	1874–1891	LV 23	1874–1876
					LV 20	1876–1880
		40° 26.8'N	73° 55.3'W	1891–1907	LV 7	1881–1902
		40° 26.6'N	73° 55.2'W	1907–1962	LV 11	1902–1925
					LV 69	1925–1936
					LV 87	1936–1942
					WW II	1942–1945
					LV 78	1945–1947
					L 87	1947–1962
28	Barnegat, NJ	39° 45.0'N	73° 56.0'W	1927–1969	LV 79	1927–1942
					WW II	1942–1945
					LV 9	1945–1967
					LV 110	1967–1969
29	Northeast End, NJ	38° 57.9'N	74° 32.4'W	1882–1894	LV 44	1882–1926
		38° 57.8'N	74° 29.6'W	1894–1932	LV 111	1926–1932
30	Five Fathom Bank, NJ	38° 53.5'N	74° 39.0'W	1837–1881	(unknown)	1837–1839
					LV 18	1839–1869
					LV 37	1869–1876
		38° 48.4'N	74° 36.2'W	1881–1894	LV 40	1877–1904
		38° 47.3'N	74° 34.6'W	1894–1972	LV 79	1904–1924
					LV 108*	1924–1970
					LV 110	1970–1971
					WLV 189	1971–1972
31	Overfalls, DE	38° 48.0'N	75° 01.4'W	1898–1944	LV 46	1898–1901
					LV 69	1901–1925
		38° 47.1'N	75° 00.7'W	1944–1960	LV 101	1925–1951
					WLV 605	1951–1960
32	Brandywine Shoal, DE**	38° 59.0'N	75° 08.0'W	1823–1850	N	1823–1850
33	Fourteen Foot Bank, DE	39° 03.0'N	75° 11.0'W	1876–1886	LV 19	1876–1886
34	Upper Middle, DE	39° 08.8'N	75° 14.2'W	1823–1875	X	1823–1845
					LV 19	1845–1875

Lightship Stations and the Ships That Served Them

#	STATION NAME	LATITUDE	LONGITUDE	YEARS	SHIPS ASSIGNED	YEARS
35	Delaware, DE	39° 08.8'N	75° 14.2'W	1960–1970	LV 107	1960–1965
					LV 116	1965–1970
36	Fenwick Island Shoal, DE	38° 26.3'N	74° 53.4'W	1888–1891	LV 37	1888–1892
		38° 26.0'N	74° 50.8'W	1891–1909	LV 52	1892–1930
		38° 27.6'N	74° 46.4'W	1909–1933	LV 116	1930–1933
37	Winter Quarter Shoal, VA	37° 57.0'N	75° 05.5'W	1874–1897	LV 24	1874–1875
					LV 37	1875–1876
		37° 56.5'N	75° 04.1'W	1897–1909	LV 45	1876–1908
		37° 55.5'N	74° 56.4'W	1909–1960	LV 91	1908–1934
					LV 107*	1934–1960
38	Cape Charles, VA	37° 05.5'N	75° 43.0'W	1888–1922	LV 4	1888–1891
	Chesapeake, VA				LV 49	1891–1916
		37° 05.0'N	75° 40.3'W	1922–1928	LV 101	1916–1924
					LV 80	1924–1927
		36° 58.7'N	75° 42.2'W	1928–1965	LV 72	1927–1933
					LV 116*	1933–1965
39	Tail of Horseshoe, VA	36° 58.6'N	76° 02.5'W	1900–1922	LV 71	1900–1901
					LV 46	1901–1922
40	Willoughbys Spit, VA	37° 00.1'N	76° 14.8'W	1820–1872	C	1820
					Q	1821–1847
					(unknown)	1847–1867
					LV 21	1867–1868
					LV 23	1868–1872
41	Bush Bluff, VA	36° 54.6'N	76° 20.3'W	1891–1918	LV 46	1891–1893
					(unknown)	1893–1895
					LV 97	1895–1918
42	Craney Island, VA**	36° 53.0'N	76° 20.0'W	1820–1859	C	1820–1859
43	Thirty Five Foot Channel, VA**	37° 05.0'N	76° 07.0'W	1908–1919	LV 45	1908–1918
					buoy	1919
44	York Spit, VA	37°12.0'N	76° 13.7'W	1855–1870	T	1855–1861
					(vacant)	1861–1863
					LV 22 [12(2)]	1863

Lightship Stations and the Ships That Served Them

#	STATION NAME	LATITUDE	LONGITUDE	YEARS	SHIPS ASSIGNED	YEARS
					(vacant)	1864–1867
					LV 24	1867–1870
45	Wolf Trap, VA	37°23.0'N	76° 10.0'W	1821–1870	S	1821–?
					T	1855–?
					(vacant)	1861–1864
					LV 22 [12(2)]	1864–1870
					(vacant)	1870–1893
		37°23.0'N	76° 11.6'W	1893–1895	LV 46	1893–1895
46	Windmill Point, VA	37°34.8'N	76° 11.5'W	1834–1869	U	1834–1861
					(vacant)	1861–1863
					(unknown)	1863–1867
					LV 21	1867–1869
47	Bowlers Rock, VA	37° 49.2'N	76° 43.3'W	1835–1868	O	1835–1861
					(vacant)	1861–1863
					LV 28	1863–1868
48	Smith Point, VA	37° 52.7'N	76° 10.1'W	1821–1897	B	1821–1861
					(vacant)	1861–1862
					LV 23	1862–1868
					(vacant)	1868–1895
					LV 46	1895–1897
49	Janes Island, MD	37° 57.6'N	77°0 5.4'W	1853–1867	(unknown)	1853–1867
50	Lower Cedar Point, MD	38° 21.0'N	77° 00.5'W	1825–1867	DD	1825–1861
					(vacant)	1861–1864
					LV 24	1864–1867
51	Upper Cedar Point, MD	38° 24.0'N	77° 03.5'W	1821–1867	LL	1821–?
					EE	?–1859
					SS	1859–1861
					(vacant)	1861–1864
					LV 21	1864–1867
52	Hoopers Strait, MD	38° 13.0'N	77° 05.0'W	1827–1867	LV 25	1827–1867
53	Choptank River, MD**	38° 39.8'N	76° 00.0'W	1870–1872	LV 25	1870–1872
54	Wade Point Shoal, NC**	36° 08.0'N	76° 00.0'W	1826–1855	M	1826–1855

Lightship Stations and the Ships That Served Them

#	STATION NAME	LATITUDE	LONGITUDE	YEARS	SHIPS ASSIGNED	YEARS
55	Roanoke River, NC**	35° 58.0'N	76° 42.0'W	1835–1866	MM	1835–1861
					(vacant)	1861–1863
					possible MM	1863–1866
56	Roanoke Island, NC**	35° 54.0'N	75° 44.0'W	1835–1861	RR	1835–1861
57	Long Shoal, NC**	35° 32.0'N	76° 40.0'W	1825–1867	JJ	1825–1861
					(vacant)	1861–1864
					KK	1864–1867
58	Ocracoke Channel, NC**	35° 04.0'N	76° 01.0'W	1852–1859	TT	1852–1859
59	Royal Shoal, NC**	35° 07.0'N	76° 10.0'W	1826–1867	(unknown)	1826–1867
60	Harbor Island, NC**	35° 01.0'N	76° 14.0'W	1836–1867	QQ	1836–1861
					(vacant)	1861–1863
					(unknown)	1863–1867
61	Brant Island Shoal, NC	35° 05.0'N	76° 17.0'W	1831–1863	FF	1831–?
					GG	?–1863
62	Nine Foot Shoal, NC**	35° 10.0'N	76° 02.0'W	1827–1859	SS	1827–1859
63	Neuse River, NC**	35° 05.0'N	76° 02.0'W	1828–1862	HH	1828–1862
64	Diamond Shoal, NC	35° 05.0'N	75° 20.0'W	1824–1827	(unknown)	1824–1827
	(Cape Hatteras, NC)				(vacant)	1827–1897
		35° 06.1'N	75° 16.7'W	1897–1902	LV 69/ LV 71	1897–1901
		35° 05.2'N	75° 18.7'W	1902–1936	LV 71/ LV 72	1901–1918
					LV 72	1918–1922
		35° 05.3'N	75° 19.7'W	1936–1966	LV 105	1922–1942
					buoy	1942–1945
					LV 114	1945–1947
					WLV 189	1947–1966
65	Cape Lookout Shoals, NC	34° 20.0'N	76° 25.0'W	1905–1907	LV 80	1905–1924
		34° 18.4'N	76° 24.4'W	1907–1933	LV 107	1924–1933

Lightship Stations and the Ships That Served Them

#	STATION NAME	LATITUDE	LONGITUDE	YEARS	SHIPS ASSIGNED	YEARS
66	Frying Pan Shoal, NC	33° 35.0'N	77° 50.0'W	1854–1894	D	1854–1860
					(vacant)	1860–1863
					LV 32	1863–1864
					LV 29	1865–1871
					LV 34	1871–1875
					LV 29	1875–1877
					LV 32	1877–1883
					LV 38	1883–1888
					LV 29	1888–1892
		33° 34.4'N	77° 49.2'W	1894–1907	LV 53	1892–1896
		33° 33.8'N	77° 48.9'W	1907–1930	LV 1	1896–1911
		33° 28.0'N	77° 33.8'W	1930–1964	LV 94	1911–1930
					LV 115*	1930–1964
67	Horseshoe Shoal, NC	33° 57.3'N	77° 57.4'W	1851–1870	UU	1851–1870

* time-out for World War II ** position approximate

Bibliography

Adams, W.H. Davenport. *Lighthouses and Lightships*. New York: Charles Scribner and Co., 1870.

American Guide Series. *Delaware*. New York: Hastings House, 1938.

Ames, David L., Leslie D. Bashman and Rebecca J. Siders. *Delaware's Aids to Navigation: A Survey and National Register Eligibility Evaluation*. Newark, DE: University of Delaware, 1991.

Beach, John W. *Cape Henlopen Lighthouse*. 2nd ed. Dover, DE: Henlopen Publishing Co, 1971.

Binns, Archie. *Lightship*. New York: Reynal and Hitchcock, 1934.

Brewington, M.V. *Chesapeake Bay, A Pictorial Maritime History*. Cambridge, MD: Cornell Maritime Press, 1956.

Chapelle, Howard. I. *The History of American Sailing Ships*. New York: W.W. Norton & Company Inc., 1935.

Claflin, James W. *Historic Nantucket Lightships*. Worchester, MA: Kenrick A. Claflin & Son, 2005.

Conwell, T. Clarke. *Ships and Men of the Broadkill*. Privately published April 1966.

Delaware River & Bay Lighthouse Foundation. *Light List*. http://www.delawarebaylights.org/light_list.htm.

Bibliography

Delgado, James P. *The Maritime Heritage of the United States National Historic Landmark Theme Study*. Washington D.C.: U.S. National Park Service, 1989. http://www.cr.nps.gov/maritime/ltshipnhltheme.htm.

De Wire, Elinor. *Lighthouses of the Mid-Atlantic Coast*. Stillwater, MN: Voyageur Press, 2002.

———. *Lighthouses of the South*. Stillwater, MN: Voyageur Press, 2004.

Emory, Scott A. "The Vineyard Shipbuilding Company: From Wood Shavings to Hot Sparks." Master's thesis, East Carolina University, July 2000.

Evans, Becky W. "Old Lightship New Bedford Springs a Leak." *Standard Times of New Bedford*, June 2, 2006.

Evans, Douglas J. "The History of Cape Henlopen Lighthouse, 1764–1926." Master's thesis, University of Delaware, May 17, 1958.

Flint, Willard. *Lightships of the United States Government, Reference Notes*. Washington, D.C.: U.S. Coast Guard, 1989.

Gardiner, Robin. *The History of the White Star Line*. Hersham, Surry, UK: Ian Allen Publishing Ltd., 2001.

Gilchrist, David T. *The Growth of Seaport Cities, 1790–1825*. Wilmington, DE: The Elutherian Mills-Hagley Foundation, 1967.

Gowdy, Jim, and Kim Ruth. *Guiding Lights of the Delaware River and Bay*. 2nd ed. Sweetwater, NJ: Jim Gowdy, 1999.

Hairr, John. *North Carolina Lighthouses and Lifesaving Stations*. Charleston, SC: Arcadia Publishing, 2004.

A History of the Pilots Association for the Bay and River Delaware from 1888 to 1906. Lewes, DE: The Pilots Association for the Bay and River Delaware, 1988.

Holland, Francis Ross Jr. *America's Lighthouses, Their Illustrated History Since 1716*. Brattleboro, VT: Stephen Greene Press, 1972.

Bibliography

Hornberger, Patrick, and Linda Turbyville. *Forgotten Beacons, The Lost Lighthouses of the Chesapeake Bay*. 2nd ed. Annapolis, MD: Eastwind Publishing, 1997.

Instructions to Light-Keepers and Masters of Light-House Vessels, 1902. (A photo reproduction of the U.S. Government document by the Great Lakes Lighthouse Keepers Association, 1989.)

Lane, Anthony. *Guiding Lights*. Charleston, SC: Arcadia Publishing Inc., 2001.

Lesher, Pete. Chesapeake Bay Maritime Museum. St. Michaels, MD. http://www.cbmm.org/.

Macdonald, Betty Harrington. *Mispillion-Built Sailing Ships 1761–1917*. Milford, DE: The Milford Historical Society, 1990.

Marshall, Amy. *A History of Buoys and Tenders*. Washington, D.C.: United States Coast Guard Historian's Office. http://www.uscg.mil/history/weblighthouses/h_bouys.html

Noble, Dennis L. *Lighthouses & Keepers*. Annapolis, MD: Naval Institute Press, 1997.

Peterson, Douglas. *United States Lighthouse Service Tenders*. Annapolis MD: Eastwind Publishing, 2000.

Plummer, Norman H. *Beacons of Hooper Strait*. St. Michaels, MD: Chesapeake Bay Maritime Museum, 2000.

Putnam, George R. "Beacons of the Sea." *National Geographic Magazine* 24, no. 1 (January 1913): 1–53.

————. *Lighthouses and Lightships of the United States*. New York: Houghton Mifflin Company, 1917.

————. "New Safeguards for Ships in Fog and Storm." *National Geographic Magazine* 69, no. 8 (August 1936): 169–200.

————. *Sentinel of the Coasts*. New York: W.W. Norton & Company, Inc., 1937.

Bibliography

Ridgley-Nevitt, Cedric. "A Light-Vessel of 1823 Built by Henry Ekford." *The American Neptune* 5, no. 2 (April 1945): 115–120.

Schiff, Wilfred H. *The Delaware River*. Philadelphia: Commercial America, April 1915.

Talbot, Frederick A. *Lightships and Lighthouses*. Philadelphia: J.B. Lippincott Company, 1913.

Thompson, Frederick L. *The Lightships of Cape Cod*. Portland, ME: Congress Square Press, 1983.

Tilp, Frederick. *This Was Potomac River*. Alexandria, VA: Frederick Tilp, 1978.

Trapani, Bob, Jr. *Lighthouses of Maryland and Virginia*. Elkton, MD: Myst and Lace Publishers, 2006.

————. *Lighthouses of New Jersey and Delaware*. Elkton, MD: Myst and Lace Publishers, 2005.

United States Coast Guard. *Light List*. http://www.navcen.uscg.gov/pubs/LightLists/V2COMPLETE.PDF

United States Coast Guard Historian. http://www.uscg.mil/history/.

U.S. Congress. House. *Lightship for Fenwick Island Shoal*. H.R. Report No. 2238, May 29, 1890.

U.S. Congress. Senate 11. *Report of the Secretary of the Treasury on the Expediency of Requiring Vessels Navigating Along the Coast to Carry Lights*. December 15, 1846.

Van Cleave, Richard H. Ketchikan Museums, Alaska. http://www.city.ketchikan.ak.us/departments/museums/tongass_current.html.

Williams, William Henry. *Delaware*. Sun Valley, CA: American Historical Press, 1999.

About the Author

Wayne Kirklin serves as the associate historian of the Overfalls Maritime Museum Foundation, the organization restoring one of America's few remaining lightships, LV *118*. This vessel is located on the Lewes & Rehoboth Canal in historic Lewes, Delaware.

Wayne grew up in Delaware and graduated from the University of Delaware. He moved back to the state in 2001 after twenty-two years as a banker in New England and an equal number of years as a college professor in Ohio.

Wayne has been a boater for many years and has published a number of articles on nautical subjects. All royalties from this book will be donated to the foundation for restoration work.

Please visit us at

www.historypress.net